NORTHUMBERLAND'S MILITARY HERITAGE

Neil R. Storey

AMBERLEY

Acknowledgements

The author would like to thank Newcastle Central Library Local Studies Library; Lesley Freyter at The Fusiliers of Northumberland Museum, Alnwick; Major Charles Whiteley, 101 Regiment, Royal Artillery; Dean Christopher Dallison and Kate Sussams at St Nicholas Cathedral; The Tyneside Scottish Association; Ian Johnson; and my dear partner Fiona Kay.

For my dear pal Ian Johnson and wor lads and lasses who did their bit when their country needed them. We will remember them.

First published 2017

Amberley Publishing
The Hill, Stroud
Gloucestershire, GL5 4EP

www.amberley-books.com

Copyright © Neil R. Storey, 2017

Front cover logo source material courtesy of Gerry van Tonder.

The right of Neil R. Storey to be identified as the Author of this work has been asserted in accordance with the Copyright, Designs and Patents Act 1988.

ISBN 978 1 4456 7324 0 (print)
ISBN 978 1 4456 7325 7 (ebook)

All rights reserved. No part of this book may be reprinted or reproduced or utilised in any form or by any electronic, mechanical or other means, now known or hereafter invented, including photocopying and recording, or in any information storage or retrieval system, without the permission in writing from the Publishers.

British Library Cataloguing in Publication Data.
A catalogue record for this book is available from the British Library.

Origination by Amberley Publishing.
Printed in Great Britain.

Contents

	Introduction	5
1.	Romans, Conquerors and Castles	7
2.	Border Wars	16
3.	The Wars of the Roses	18
4.	The Battle of Flodden	19
5.	Bishops Wars and Civil War	23
6.	Jacobite Risings	28
7.	The Napoleonic Wars	32
9.	The Victorian and Edwardian Eras	42
10.	The First and Second World Wars	55
11.	The Royal Northumberland Fusiliers	78
12.	Victoria Cross Heroes of Two World Wars	90

Map of Northumberland engraved by Benjamin Baker, 1793. Note the 'Picts Wall' and the German Ocean.

Introduction

> 'We must have bloody noses and cracked crowns.'
> *Henry the Fourth Part 1,* William Shakespeare

Anyone who has spent time in the military services, no matter where they served and no matter what services they served in, will almost certainly have had a comrade known to all as Geordie. Being amiable, honest, decent and hard working are all qualities to be respected in the men of the North. Undoubtedly they are good fighting men and brave – you can rely on that – but it is the wit and outlook of the Geordie lads during some of the darkest situations that can get you through and pull you up by your boot straps when it really matters. That is what marks these men apart from others and has made them the backbone of the British armed forces for centuries.

We only need to look back to the First World War to see the Northumberland Fusiliers expanded from the typical seven battalions found in a number of the larger county regiments of the day to an incredible fifty-two battalions, making it the second largest line infantry regiment in the entire British Army. It should also be remembered that this

Bandmaster and the youngest bandsman of the Northumberland Fusiliers carrying 'The Drummer's Colour' on St George's Day, c. 1908. The red-and-white roses that were worn in the caps of the 5th on the day traditionally represent St George.

was achieved before conscription was introduced; they were all volunteers, such was the spirit of the men of Northumberland. But they would just shrug it off as no special achievement, arguing they had joined up because it made a change from the daily dangers they faced working down the pits or working on shipyards. Others said, in all honesty, that they went because all their marras were going and they didn't want to miss out. If their king and country needed them the Geordie lads just did their bit.

What has built the character of these men? I believe it is a combination of their ancestry; it's in their blood, and the long martial history of the place where they are born and raised. Northumberland is a county of outstanding beauty and diversity from bustling towns and cities to old mining towns, quiet rural villages and many miles of magnificent coastline. The hills of the county reward the traveller with wide panoramas of breathtaking countryside. Up towards the northern borderlands with Scotland the views are dotted with medieval castles and fortifications while the landscape in the south is bisected by the remains of the Roman wall. All of these are now picturesque features to tourists but they are also telling reminders of the county's long and violent past including Roman occupation, border wars, rebellions, raiders and reivers. In the past, if there was a war or uprisings the ordinary man of Northumberland was usually dragged into the fighting, so after centuries of conflict it's not really surprising they have the qualities and outlook they have.

This book does not pretend to be encyclopaedic. Instead I hope it will provide an interesting and useful volume both for those who know something of the local and military history of Northumberland as well as those beginning their own journeys of discovery into the military past of the land that breeds heroes.

<div style="text-align: right">Neil R. Storey, 2017</div>

The Tynemouth Battery, 2017.

1. Romans, Conquerors and Castles

Hadrian's Wall – Frontier of the Roman Empire

When Hadrian became emperor there were uprisings on many of the far-flung corners of the Roman Empire. He determined to consolidate what the Romans had already achieved through military might by constructing fixed frontiers at the limits of Roman expansion. In Britannia, Hadrian ordered the construction of a wall to separate the barbarians from the Romans. Construction started in the east during AD 122 and by AD 128 the wall was complete, spanning 73 miles from Bowness-on-Solway to Wallsend on Tyne. Standing 8–10 feet tall, it incorporated seventeen forts and a series of eighty milecastles constructed between the forts along the wall at intervals of around one Roman mile – hence the name. Varying in size, each milecastle accommodated between twelve and thirty soldiers and controlled gateways through the frontier. On either side of each milecastle were observation turrets that were also built into the wall at intervals of about one-third of a Roman mile, manned by detachments of men from their nearest milecastle. The wall not only acted as a barrier but also provided a fixed defence that enabled the army to communicate quickly and efficiently in the event of attack on any part of the frontier. The wall also stood as a physical symbol of Rome's dominance and control.

The wall ran largely parallel with the Stanegate road from Carlisle (Luguvalium) to Corbridge (Coria) and is constructed from locally quarried sandstone and clay. Sections of the wall were built by different detachments of legionary soldiers sent up from all three legions of Britain from their bases in the south and they left celebratory inscriptions upon the sections they constructed, leaving future generations with a remarkable record of the units that worked on the wall.

The majority of troops engaged on the wall were not actually Romans but people from across the vast Roman Empire from Europe to the Middle East, while Britons

A silver denarius coin depicting the head of Roman Emperor Hadrian, who reigned AD 117–138.

Above: A reconstruction of a milecastle typical of those built along Hadrian's Wall at Roman Vindolanda Museum.

Left: The ruins of Milecastle No. 42 and Hadrian's Wall near Cawfield Crags.

from defeated tribes conscripted into the Roman army would usually be sent to serve elsewhere in the empire.

Every aspect of these soldiers' lives were controlled by the army and a huge amount had to be accomplished every day to keep the frontier working. Soldiers would undertake guard duties, weapons training, physical exercise, fatigues and marching patrols. Beyond the walls of the fort marching camps needed to be erected, defensive ditches dug and fortifications established, movement of local people both sides of the frontier had to be policed and supplies protected.

Hadrian's Wall snaking across the countryside at Cuddy's Crags, near Housteads.

The longest occupied fort on the line of the wall was Vindolanda built about the year AD85, occupation continued until the end of Roman Britain in AD 410. In 1973 excavations at the site revealed 752 wooden writing tablets dating from first and second centuries AD, which were at that time the earliest surviving examples of the use of ink letters in the Roman period. The tablets included a huge variety of correspondence from enquiries about supplies and farming to military matters, family letters, an order for socks, underpants and sandals and even an invitation to a birthday party.

Hadrian's Wall was the most important structure built by the Romans in Great Britain and remained the north–west frontier of the Roman Empire for over 200 years. Hadrian's Wall was declared a World Heritage site in 1987.

Anglo-Saxons and Vikings

The departure of the Romans in 'AD 410' left our borders and coastline undefended and the north was vulnerable to attack, not just from tribes from the 'badlands' beyond Hadrian's Wall but also from Germanic raiders – the Angles and the Saxons. They soon realised that Britannia was theirs for taking from the native Britons and they began Anglo-Saxon colonies in the east and the north.

By the seventh century a number of great Saxon kingdoms had emerged across Britain. Ethelfrith was the first king to rule both Bernicia and the neighbouring land of Deira making the mightiest kingdom of them all that spread from the Firth of Forth in the north to the Humber in Lincolnshire in the south, a kingdom that would become known

The wooden cross erected in 1928 near the presumed site of the original erected by Oswald before the Battle of Heavenfield in AD 634.

as Northumbria. When Ethelfrith died in 616 the kingdom passed to Edwin and the young sons of Ethelfrith; Princes Eanfrith, Oswald and Oswiu fled north into exile.

When Edwin was killed fighting the armies of Cadwalla of Gwynedd and Penda of Mercia at Hatfield Chase in 633 Prince Eanfrith returned to claim the throne of Bernicia but the kingdom was divided with Edwin's cousin Osric ruling Deira. Cadwalla fought on and both Eanfrith and Osric fell to his sword. Cadwalla then forged a bloody trail of wholesale slaughter and firing of villages across Northumbria in an attempt to take the kingdom in AD 634.

Cadwalla and his men marched up Dere Street, the old Roman road from York, but Prince Oswald came out from his exile to organise and lead a small Northumbrian army to rescue his people. Oswald knew they were small in number but he chose his battleground well. In the hills above Hexham he found a narrow plateau at Heavenfield (Hefenfelth). On the night before battle he ordered some of his men to go into the woods, fell a tree and return with two long straight beams of wood. A cross was fashioned from the timber and he held it upright in a hole while his soldiers heaped soil around it. The soldiers then gathered around and kneeled in prayer for victory in battle.

Cadwalla and his troops attacked at dawn. Oswald's men held their ground as wave after wave attacked but failed to outflank the Northumbrians. The Welsh attack broke, Cadwalla fled and his men were left in disarray. The Northumbrians pursued them and cut them down; even Cadwalla himself was slain a short distance away at Denis's Brook (thought to be Rowley Burn).

According to the Venerable Bede, writing around 100 years later, the cross raised by Oswald before the battle was the first sign of the Christian faith in Bernicia. The original

The field known as Mould's Close to the south of Oswald's cross where numerous bones and swords hilts believed to be from the dead from the Battle of Heavenfield have been turned up by the plough over the years.

cross is long gone, having been picked away by pilgrims for relics, but a chapel and another wooden cross were erected on the site of the battle. It is the field across the road to the south of this cross, known as Mould's Close, that has over generations yielded up remnants of weaponry and bones that bear mute testimony to the costly toll of the Battle of Heavenfield.

Oswald was proclaimed king and Northumberland was united once more and he centred his power base around the royal palaces at Yeavering, Maelmin (Milfield) and Bamburgh. In thanksgiving for his victory Oswald granted the nearby tidal island of Lindisfarne to the monks of Iona to establish a monastery and a bishopric by the power base of the Northumbrian kingdom.

It was Lindisfarne Monastery, one of England's holiest shrines, that suffered the first Viking raid on Britain, indeed their first significant attack in Western Europe, in June 793. Monks were killed in the attack. Some of them were driven into the sea to drown while others were taken away to become slaves, and the monastery was plundered of its gold and silver. In the following year the Vikings attacked Jarrow Priory and further raids ensued along Northumbrian coast and up the rivers Tyne and Aln. Soon after bloody battles were fought and villages and religious houses such as Tynemouth Priory were ransacked, looted and fired. Sadly the ancient accounts of the Viking raids and battles recorded in the likes of the *Anglo Saxon Chronicle* and the stories of battles led by such characters as Halfdan Ragnarsson and Ivar the Boneless, although based on actual people and events, are unreliable in their details; identities and locations are disputed and the extent of Viking incursions, power and settlement in Northumberland are hotly debated.

What we can be sure of is that the clashes were bloody and terrifying. A prayer handed down the years hails: '*A furore Normannorum libera nos, Domine*' ('From the fury of the Norsemen deliver us, O Lord').

As an interesting footnote, a thousand years and more since the Vikings modern DNA testing shows high percentages of Scandinavian ancestry remains evident in the people of Northumberland.

The Normans

Duke William of Normandy landed in Sussex with his invasion force in 1066 and during the ensuing Battle on Senlac Hill (now known as the Battle of Hastings) Harold the Anglo-Saxon King of England lost his life, his army was defeated and William was crowned King of England on Christmas Day in 1066.

As the Normans occupied England people of the North refused to roll over and submit; many rebelled and Scotland was certainly not conquered. Assaults by small armed bands and armies from over the border and rebels within the county had to be put down with a show of Norman military might. Norman governance and power was reflected in the construction of an impressive stone castle at Newcastle in 1080 and more would soon follow.

Alnwick was besieged by King Malcolm of Scotland in 1093. He had entered Northumberland with a great army but Malcolm and his son were slain in the siege and his army almost totally destroyed. The lesson was learned and made more pressing following the rebellion raised by Robert de Mowbray, Earl of Northumberland, against William Rufus in 1095. A stronghold further north was thought wise and the construction of a stone castle at Alnwick was begun in 1096.

The keep of Newcastle Castle as it appeared in the mid-nineteenth century.

The keep of Alnwick Castle founded by Ivo de Vesci in the eleventh century. After it was bought by the Percy family, the Earls of Northumberland, they rebuilt it as a major fortress on the Anglo-Scottish borders.

Castles

Battles fought on Northumbrian soil between armies from both sides of the border continued to bloodily punctuate the pages of Northumberlands history so it is hardly surprising that the county has the greatest number of castles and fortifications anywhere in Britain.

Between the twelfth and fourteenth centuries numerous castles were built in Northumberland among them are:

Wark on Tweed (1136). Built by Walter Espec, it was attacked by King David of Scotland in 1138 and William the Lion in 1174. The castle was destroyed by King John as he attempted to revoke the terms he sealed on the Magna Carta. The castle was rebuilt and survived attacks, sieges and attempts to storm it but as times changed the threat died down. The garrison and ordnance were withdrawn in 1633 and it drifted into ruin.

Norham (1121). Built on the orders of Ranulf de Flambard, Bishop of Durham, to protect the interests of the bishopric in northern Northumberland, it was one of the most important strongholds on the borders. Frequently attacked by the Scots, it was besieged on no less than thirteen occasions. The original castle finally fell to the cannon of James IV shortly before his defeat at Flodden in 1513.

Bamburgh (eleventh century). A fortification had stood on the Bamburgh headland since the fifth century but the old wooden fort was destroyed by the Vikings in 993. The Normans built a new castle on the site with a great stone keep erected in 1164.

Above: Bamburgh Castle, one of the most picturesque of all the Northumbrian castles and at one time thought impregnable. Its restoration was completed by local industrialist William Armstrong in the late nineteenth century.

Below: Bamburgh Castle. In 1464 it became the first English castle to fall to artillery fire, depicted in an eighteenth-century engraving when it still showed the scars of assault upon it.

Impregnable early siege warfare, this changed as cannon became prevalent and it became the first English castle to fall to artillery fire after a nine-month long siege by Richard Neville, 16th Earl of Warwick.

Harbottle (c. 1157). Built by the Umfraville family at the request of Henry II, it was taken by the Scots in 1174. It was besieged by the Scots on at least two more occasions and was captured by Robert the Bruce in the fourteenth century. It was the residence of the Warden of the Middle Marches for many years. The castle fell into decay from the seventeenth century.

Prudhoe (eleventh century) was originally built as a motte-and-bailey by the Normans as part of a series of castles along the Tyne. It was rebuilt with a huge rampart, stone curtain wall and gatehouse during the twelfth–thirteenth centuries by the Umfraville family. It survived two sieges by William the Lion of Scotland in the 1170s.

Warkworth (twelfth–thirteenth centuries). Originally a motte-and-bailey, the stone castle and defences were erected by Robert FitzRoger between 1199 and 1214. Besieged by the Scots in 1327, it passed to the Percy family in 1332 and became the favoured residence of the Percy family for the next 400 years.

Chillingham (twelfth century). As a stronghold it withstood an attack by William Wallace in 1297 and was fortified as a castle in 1344. Chillingham was regularly used as a staging post for English armies as they advanced to Scotland and was subject to attacks from the Scots. In 1513 it was attacked by an invading Scottish army under James IV and survived a serious assault during the 'Pilgrimage of Grace' in 1536, but it never fell to an attacking enemy.

Ford (1287). First recorded in 1287, it was built as a fortified manor house. It was crenellated in 1338 and became one of the second line defences against attacks from the Scots. On 1513 the castle was attacked by James IV of Scotland and the king stayed there the night before his death at the Battle of Flodden. The retreating Scots abandoned the castle and torched it.

Dunstanburgh (1313). Built by Thomas, Earl of Lancaster, it was inherited by John of Gaunt in the 1380s, who upgraded the fortifications of the castle and it became his power base as Lieutenant of the Scottish Marches. During the Wars of the Roses the castle sided with the House of Lancaster. It was compelled to submit to the Yorkists in 1461 but its joint constable Sir Ralph Percy declared for Lancaster again the following year. In June 1464 the Yorkists finally secured the castle and it was left to fall into ruin.

Morpeth (eleventh century). Originally a motte-and-bailey, it was destroyed by King John in 1216. A new castle was built in 1342–49 by William de Greystock. The castle's one significant military event came in 1644 when a garrison of 500 Lowland Scots who had declared for Parliament held out for twenty days against a force of 2,700 Royalists. The damage suffered in the attack was so severe that the castle was left to ruin.

Langley (c. 1350). Seat of the Barons of Tynedale in the twelfth century, the present castle was built by Sir Thomas de Lucy. Langley Castle passed to the Percy family in 1398 but when they quarrelled with Henry IV over the spoils of the Battle of Homildon Hill and supported rebel forces against him the king marched on Northumberland and his forces fired Langley in 1405. It remained a ruin until 1882 when it was bought and restored by local historian Cadwallader Bates and today is a luxury hotel.

2. Border Wars

Bloody battles, attacks and raids over the borderlands of England and Scotland continued for centuries. Among the more serious and destructive campaigns was that led by Sir William Wallace in 1297 when, after beating the English army at the Battle of Stirling Bridge, he led a large-scale raid into Northumberland and Cumberland. As his forces made their way across the county they slaughtered many inhabitants of villages and towns and laid waste to numerous settlements. They burned Hexham and its priory, destroyed Corbridge, burnt the nunnery at Lambley and attacked the nuns. Proceeding down the north of the Tyne they attacked and plundered Ryton. As they approached Newcastle the townsmen made every preparation to repulse the attack and sallied forth to engage them but the Scots turned another way. Wallace's force was also repulsed near Alnwick Castle where the garrison sent forth parties to attack the marauders.

The Hotspur Gate, otherwise known as Bondgate Tower, Alnwick, photographed c. 1900. It was built in the fifteenth century to be part of a town wall around Alnwick that was never completed.

Wallace was finally captured in 1305, tried, found guilty of treason and was hanged, drawn a quartered. His head was displayed on a spike on London Bridge while Berwick, Newcastle, Stirling and Perth each displayed one of his 'quarters' (limbs) on public buildings or structures as a warning to others who may be tempted to do as he did. In Newcastle his arm was displayed on the battlement of the Bridge Tower near the centre of the old Tyne Bridge.

The threat from the Scots was refreshed in the minds of the people of Northumberland. In Newcastle his arm was displayed on the Battlement of the Bridge Tower near the centre of the old Tyne Bridge. More farmhouses and manors were fortified and towns already with castles were enclosed in fortified stone walls with bastion gateways such as Newcastle (thirteenth century), Berwick (fourteenth century) and Alnwick (fifteenth century).

Although expensive, the investment in the new or improved defences were soon proved worthwhile, so when King David of the Scots invaded Northumberland with an army of 53,000 in 1342 and lay about Newcastle, the townsmen delivered a surprise attack, slaying many enemies and bringing back the Earl of Murray as a prisoner. The following morning the Scots attacked Newcastle but Sir John Neville, the captain of the castle, made a strong defence and the attackers were compelled to raise their siege and march to Durham, which they took by storm after seven days.

The border wars rumbled on; the Battle of Otterburn in 1388 owes far more to bards than it ever achieved strategically and it left around 3,000 dead and 1,000 wounded. Far more significant was the Battle of Humbleton Hill in 1402. It was a slaughter, with almost every Scot killed or captured. The victorious Percys wanted to ransom the prisoners but the king wanted to keep them as pawns to bargain with Scotland. They argued and the Percys were so incensed that they made a pact with the Scots and the Welsh to remove the king from the throne and replace him with Mortimer. As the Scots and Northumbrian armies marched to unite with Wales, they were intercepted at Shewsbury. They were decisively beaten in a vicious exchange where Harry 'Hotspur' Percy died in battle.

3. The Wars of the Roses

The two houses of Lancaster and York fought for the crown of England for thirty years and over that period Sir Ralph Percy, third son of the Earl of Northumberland, changed sides four times. Over the years 1461–64 the North of England was the hub of the action of the War of the Roses. In 1463 Percy was in the Lancastrian fold as were his castles at Bamburgh and Dunstanburgh. In 1464 Edward IV (the monarch supported by the Yorkists) sought a truce with Scotland that would enable him to take action to crush the Lancastrians in the North. John Neville, Lord Montague, younger brother of Warwick 'The Kingmaker', was despatched to escort a Scottish mission through Northumberland to safety. Learning of these plans, the Lancastrians attempted to ambush the Yorkists at Durham but this failed when they were forewarned of the attack. Montague raised more troops for his army in Newcastle and marched north but his path was barred at Hedgeley Moor by the Lancastrian troops of Sir Ralph Percy, Lord Hungerford and Lord Ros on 25 April 1464. Hungerford and Ros rapidly left the field leaving Montague and Percy to attack each other head on. Percy charged the line at full gallop and his horse, according to legend, was said to have leapt and was wounded in the process. Sir Ralph was mortally wounded soon after. Two great stones, still visible today, are said to mark 'Percy's Leap' on the battlefield.

Montague's troops rapidly dispensed with the remaining Lancastrians and he completed his mission to Scotland and returned to Newcastle. A month later on 15 May 1464 it was at Hexham that the Yorkists won a clear victory. The Lancastrian leaders were captured including Ros and Hungerford, who had deserted Percy on Hedgeley Moor, and were beheaded on Sandhill in Newcastle, thus bringing a temporary halt to the wars in the north.

Part of the field of the Battle of Hedgeley Moor, viewed from near the stones said to mark 'Percy's Leap'.

4. The Battle of Flodden

Flodden Field is etched bold as one of the most famous battles in the history of Britain because it was the last great battle to be fought between the Scots and the English.

The year 1513 saw Henry VIII on campaign in France and James IV of Scotland, invoking the 'Auld Alliance' with France, had crossed the Tweed near Coldstream in August with 100,000 men. The castles at Norham, Etal and Ford were rapidly taken. James then emplaced his cannon and established his camp on Flodden Hill, and made his headquarters at Ford Castle.

Thomas Howard, Earl of Surrey, had been entrusted with the defence of the north during Henry's absence. Despite being seventy years old Howard was an experienced and brave fighting man who saddled up and advanced northwards calling upon the men of Northumberland and Durham to join his forces at Newcastle. He advanced from the town with an army of over 30,000 men and marched to Alnwick, Bolton and Wooler. Surrey had hoped to draw the Scots out to do battle on Millfield Plain but they were unwilling to give up their position on the high ground.

Despite his troops being cold and their rations limited Surrey boldly marched his army on a wide flanking manoeuvre. They made camp at Barmoor where, masked by the hills and high ground between the woods and the Scottish encampment, they spent

James IV of Scotland (1473–1513).

the night of 8–9 September. James's advisers suggested Surrey was in fact heading for Berwick to reprovision in preparation for a counter invasion of Scotland. On the morning of 9 September 1513 Surrey divided his forces with his vanguard and artillery train crossing Twizel Bridge and his rearguard crossing the River Till at the ford near Heton Castle, thus completing the loop behind the Scots redoubt after a 12-mile forced march. Surrey was ready to attack from the north towards Branxton and by doing so he had also cut off the Scot's line of retreat to their homeland.

Over the time of their campaign many of the Scots had already decided to return home and when the battle lines were drawn the opposing forces on Flodden Field would be equally matched. However, the Scots had been caught off-guard and James was forced from Flodden Hill and had to move his army, hastily setting up new defensive positions a mile or so across country on the ridge of Branxton Hill. As the Scottish troops redeployed the English took up their positions and drew up their divisions on the ridge near where Branxton village now stands.

Battle commenced in late afternoon as the light was failing. It had been raining heavily for most of the day and the battle would be fought amid a squally gale. In the opening artillery duel the heavy Scottish guns were out performed by the lighter, more accurate English field guns.

The first attack saw Scottish pikemen under Lords Hume and Huntley descend Branxton Hill and rout the English right flank commanded by Edmund Howard. Badly outnumbered, the situation was only narrowly saved by the timely intervention of the English cavalry under Lord Dacre, who gave Howard's troops time to regroup.

The main Scottish troops led by noblemen Errol, Crawford and Montrose saw the success of the first attack and confidently descended Branxton Hill but they were caught out by

Today despite a drainage ditch having been dug, the mud at the bottom of Branxton Hill on Flodden Field makes it a difficult place to ensure a dry footpath, even in the summer, and reminds us what a treacherous place this was to fight a battle.

the deceptively boggy ground at the bottom of the hill. The pikemen were soon up to their knees in mud and beyond them lay the deceptively steep hill beyond where the English held the high ground. The pikemen lost momentum and as the forces clashed in the marshy valley it soon became a deadly killing ground that ran red with blood as the English used their billhooks to devastating effect against the faltering pike formations of the Scots.

If King James had only waited for the English to attack up the slopes of Branxton Hill the battle may have had a very different outcome. James was unable to hold back his troops and he too followed down the slope and joined the melee. Lennox and Argyle also led their troops in to assist their king but this only compacted more troops into the muddy killing ground that was already littered with bodies and discarded pikes, causing crush injuries and chaos. King James was boxed in and slain. The English longbowmen under Lord Stanley saw their easy target and rained down their arrows as they arrived through Crookham Dene and the fate of James's army was sealed.

An estimated 4,000 Englishmen and 10,000 Scots, nobles and soldiers were slain on Flodden Field, a rate of slaughter that exceeds some of the Battle of the Somme during the First World War, another battle cursed by mud.

Right: The Battle of Flodden, 1513, from a contemporary engraving. The body of the slain James IV lays in the left forground.

Below: The Flodden battlefield monument erected in 1910 atop Piper's Hill, overlooking the field of battle and surrounding countryside.

Border troubles did not end with the Battle of Flodden; indeed raids by rebels and reivers (violent thieves who crossed the border to steal livestock) stained the borders with blood for centuries. Fortifications, Peel towers (fortified tower houses to keep watch and light warning beacons if danger approached), bastle houses (fortified farm houses) and Barmkins (ancilliary buildings used to lock away livestock) were erected across the county for protection from the raiders.

5. Bishops Wars and Civil War

Charles I had made changes to the Church and church services but it was the attempt of Archbishop Laud to introduce a new prayer book that provoked open hostility between the Scots and the English. The Scots signed a solemn promise or covenant to oppose the king's religious reforms. Charles headed north at the head of his army to meet with the Scottish covenanters. Arriving at Newcastle around 5 May, he stayed for around ten days and was received with testimonials of duty and affection. Proceeding to the borderlands the conflict was settled without battle and both sides signed a treaty that become known as 'The Pacification of Berwick'. But neither side were really satisfied.

The Scots retained their army and Charles resolved to muster a larger and better equipped army to march north the following year. In August 1640 both armies were on the move again. Newburn Ford, just 6 miles from Newcastle, was the nearest point to the town where the river could be forded and attacked from its weaker south side. Sir Jacob Astley, Governor of Newcastle, and Lord Conway, the garrison commander, had ensured defensive emplacements or 'sconces' on the south side of the river at Ryton Willows and Stella Haughs, had an armed garrison in Newcastle and orders had been given to repair and reinforce the city walls.

Charles I (1600–49).

Above: Stella Hall, Blaydon, headquarters of Lord Conway, the Newcastle garrison commander for the Battle of Newburn fought on 28 August 1640. Photographed *c.* 1900, Stella Hall was demolished in 1953. (Newcastle Library)

Left: St Michael's Church, Newburn, had a fine command over Newburn Ford in 1640. Scottish artillery pieces were hauled up and used in the action from the roof.

On the eve of battle Lord Conway led an army of 3,000 foot soldiers and 1,500 cavalry towards Stella and set up his headquarters at Stella Hall. He also brought twelve cannon with him, believing this would be sufficient because the Scottish forces had none. He was wrong.

General Alexander Leslie led a well-trained and equipped Scottish army of 20,000 foot and 2,500 horse. Crossing into Norhumberland by way of Wooler, Eglingham and Netherwitton, they camped at Heddon Law on 27 August where they had clear view of the English troops preparing their defences at Newburn. Under the cover of darkness Leslie's master gunner Alexander Hamilton deployed his heavy cannon on the high ground at Hallow Hill, Rye Hill, Teasdale Hill and in front of the church. He also distributed around fifty smaller field pieces hidden in the hedges of the village; one was also hoisted on top of the church roof overlooking Newburn Ford The Scottish artillery dominated the English positions. Leslie's musketeers took position in the church, houses and lanes of Newburn and his cavalry waited on the slopes of the hills above the village.

When the sun rose on 28 August both sides were still preparing for battle when the first shot was fired as one of the Scottish troops watered his horse in the Tyne. But when the river was at its lowest in early afternoon the Scottish cavalry made their first advance. Soon the deafening roar of the cannons and the staccato crack of the muskets shattered the air and they were repulsed. The ensuing artillery exchanges saw the sconces suffer from the focus of the fire. The English cannons were at a disadvantage in their replies because they were firing in the river valley. Colonel Lunsford was unable to restrain his men and they started to abandon their positions. Soon the Scots were crossing the river and captured the first of the sconces, turning the guns on the English.

The English cavalry under Henry Wilmot bravely charged at the attackers and forced a temporary retreat of the Scots, but they came again. The English were hopelessly outnumbered and the second sconce was also breached. Wilmot, with Captains Sir John

Newburn Ford has changed a lot since 1640 and a bridge now occupies the crossing that was the fulcrum of the action.

Digby and Daniel O'Neill, made one last attempt to rally the cavalry and troops and led a counter attack. It failed and they were captured along with many of their men.

After the rout of his forces at Newburn Lord Conway decided Newcastle could no longer be defended and withdrew the garrison to Durham. General Leslie and his troops entered Newcastle unopposed and triumphant on 30 August and occupied the town for a year. The defeat of the king's army forced Charles to recall parliament in November and deal with it in earnest for the first time in eleven years because it was the only way he could hope to raise the £200,000 to buy off the Scots for the return of Newcastle, thus bringing to an end Charles's attempt to rule without parliament. The Battle of Newburn was the only battle of the Second Bishop's War but it would prove to be one the sparks that that ignited a Civil War that divided a country between King and Parliament.

Civil War

By 1643 the country was in a state of all out civil war but it had reached a stalemate and Parliament negotiated a religious and military alliance with the Covenanters in Scotland and in January 1644 General Leslie, victor of Newburn, led his troops to Newcastle again. Meanwhile, William Cavendish, Marquis of Newcastle, led his troops north from York to counter the Scottish incursion. Flooding around Morpeth halted Leslie's advance and he remained there a few days giving Cavendish more time to reach Newcastle; indeed he and his troops arrived just a few hours before the Scots appeared to the north of the town.

The Scots successfully attacked and captured outworks to the north–east of the city but their artillery was delayed and they were unable to mount a full-blown assault on the town. Indeed it was soon apparent to Leslie that Newcastle's defences had been improved and were capable of withstanding a long siege. Leaving six regiments to blockade the town Leslie crossed the Tyne at Ovingham and marched to Sunderland where the townsmen declared for Parliament.

An eighteenth-century view of Newcastle demonstrates what an attractive target the lantern of the tower of St Nicholas' Church would have presented for the gunners of the Parliamentary forces.

Cavendish cautiously followed the Scots. There were subsequent skirmishes but it would be at Marston Moor on 2 July where both entered a field of battle. In two hours the Royalist forces were defeated. The Marquis of Newcastle's regiment of Whitecoats refused to surrender and made a last stand where all bar thirty of them were cut down.

After the battle Leslie returned to Newcastle and found the troops he had left behind had been joined by Scottish reinforcements under the Earl of Callender and were conducting an attack on the town. Callender also took Gateshead and bombarded Newcastle from the riverside with five batteries of Scottish cannon. When Leslie arrived the river was blockaded by boats and the town was almost completely surrounded; only Shieldfield Fort held out beyond the walls. The defenders of Newcastle numbered around 1,700 consisting of 800 men of the trained bands and 900 volunteers, conscripted men, miners, keelmen and tradesmen.

As the siege began to bite supplies of ammunition and food began to become scarce and dissent occurred among the civilian population who pressed for capitulation, but Newcastle Mayor Sir John Marley wanted to fight on. The Scottish commanders prepared for a final assault using colliers from Benwell and Elswick to undermine the walls but they did not do so without offering the town council the option of an honourable surrender, which was again refused by Marley. Leslie grew impatient and sent the infamous threat to destroy the magnificent lantern of the tower of the church of St Nicholas unless they surrendered immediately. Marley replied by moving some of the most important prisoners to be held in the lantern itself warning Leslie: 'If it was to fall it should not fall alone; that the same moment he destroyed the beautiful structure, he should bathe his hands in the blood of his countrymen.'

In reality it was little more than a delaying tactic. The lantern was not destroyed but the intense bombardment came, mines were exploded, the walls breached, and the fighting was hard and desperate as the defenders were driven from the walls to the streets. Newcastle fell to the Scots and the houses of the inhabitants were plundered. Mayor Marley and a few of his confederates fled to the castle keep but after two days they also surrendered.

Newcastle and its motley band of defenders had doggedly held out for three months. Their bravery and fortitude was remembered when the house of Stuart was restored and the town was granted its motto: 'FORTITIER DEFENDIT TRIUMPHANS' ('TRIUMPHING BY BRAVE DEFENCE').

6. Jacobite Risings

In 1715 the Earl of Mar began a rising to gain the throne for James Stuart, 'The Old Pretender'. By early October the majority of Scotland had acquiesced to his forces and supported the rebellion and Mar marched into Northumberland with nearly 20,000 men. The Corporation of Newcastle put the town in a posture of defence before the arrival of regular English troops. They mustered their militia and trained bands at Killingworth Moor and deployed them to the walls of the town for its defence. The Earl of Scarborough, Lord Lieutenant of Northumberland, repaired to Newcastle along with his friends, and the local gentry mounted their neighbours and tenants on horseback so that the town was full of horses and men, townsmen and countrymen declaring for King George. Indeed it was the loyalty to King George that gave rise to all natives of Newcastle and its environs being known as 'Geordies'.

Some 700 volunteers from the town were armed to reinforce the local militia and trained bands. The keelmen offered a further 700 men to be ready at half an hours' warning if required. A battalion of foot and part of a regiment of dragoons also arrived in the town a few days later. It costs the town £800 (roughly £160,000 in modern money) to raise their own militia and for accommodation of the soldiers. The gates of the town were then walled up with lime and stone.

Holy Island Castle, Lindisfarne, as it would have looked at the time of the 1715 rising. Detail from an engraving by Samuel and Nathaniel Buck, 1728.

Around 300 mounted rebels arrived at Morpeth on 10 October 1715, intending to surprise Newcastle, but on learning of the vigorous defensive measures undertaken by the town they retired to Hexham. On the same day an abortive attempt to take Holy Island Castle was also made. If the rebels were successful in their campaign the stronghold was seen as the ideal place to land the Pretender. Thomas Forster MP of Bamburgh, a general in the rebel army, had accepted an audacious plan by Lancelot Errington of Denton to take the stronghold.

Lancelot and his nephew Mark Errington managed to enter the castle on a false pretence when most of the garrison were off duty and in the village. They surprised the old master gunner then bundled him, his wife and Pte Ferguson out of the gates and shut them behind them. They then hoisted the Pretender's flag and fired three canon shots landward as a signal of their success. They had expected there to be reinforcements from French privateers and Jacobite troops camped near Warkworth but all that came marching over the causeway were a party of 100 king's troops from the Berwick garrison. The Erringtons fled over the castle walls and attempted to hide themselves in the rocks until after dark when they would swim to the mainland.

Lancelot was spotted and the troops opened fire, wounding him in the thigh. Both men were taken prisoner and held in Berwick Gaol. The Erringtons escaped with the help of Jacobite sympathisers and after a journey where they hid for nine days in a pea stack at Bamburgh they reached Gateshead House and eventually got a passage out of Sunderland to France.

The rebels were obliged to surrender to the king's forces at the Battle of Preston, Lancashire. The noblemen and officers were taken to London and led through the streets. Among them were Thomas Foster and James Radclyffe, Earl of Derwentwater, who lived at Dilston Hall and had estates in Northumberland. Tried and found guilty of treason, the earl was beheaded on Tower Hill on 24 February 1716. Thomas Forster was fortunate to escape from Newgate Prison and fled to France where he served at the exiled Stuart court.

A bounty of £500 was placed on Errington's head. He even braved a few return visits. After the rebellion he and his nephew took advantage of a general pardon and returned to Newcastle where Lancelot Errington lived the rest of his life as a publican until his death in 1746, occasioned, it is said, of grief after the final defeat of the rebels at Culloden.

The '45 Rebellion

When the rebellion was raised for Bonnie Prince Charlie in Scotland in September 1745, the garrison of Berwick were stood ready to defend the town and 250 stands of arms were brought from the seat of the Earl of Marchmont and deposited in the magazines there to prevent them from falling into the hands of the rebels.

Newcastle swore loyalty to King George and the House of Brunswick with an agreement dated 19 September 1745 signed by 813 people of the town by which they voluntarily obliged themselves either to appear in person or to provide an able-bodied man to act in concert with His Majesty's forces in the town for its defence against all the king's enemies.

At 3.00 a.m. on 20 September Newcastle received news that 5,000 Jacobites were marching south from Edinburgh. Mayor Matthew Ridley immediately summoned all the inhabitants to appear at the Guildhall where he made a speech to them compelling all who

were willing to stand by the town – he had 3,000 sign up. They were immediately armed, formed into companies under officers and the militia of Newcastle mounted guard. The town walls had also been repaired and all the gates except three were walled up. A survey was undertaken to ascertain the best places to plant canon and great guns, their crews drawn from sailors and others with knowledge of their operation. They were placed at the Close-gate, Whitefriar Tower, Postern Gate, Heslop's House, Old Roper's Tower, Dobison's Tower, West-gate, Hatter's Tower, Glazier's Tower, Paviour's Tower, St Andrew's Tower, Newgate, Pilgrim Street Gate, Weaver's Tower, Cutler's Tower, Roper's Tower, Pandon-gate, Carpenter's Tower, Sand-gate, on the wall above the pant, Broad-chare, Sandhill corner, Bridge End and at the Mayor's House.

During the rebellion the inhabitants of Berwick formed themselves into fifteen volunteer companies, which did the duty of the garrison without pay. On 21 September some 700 Dutch troops landed on a Glasgow man-o'-war at Berwick and on 24 September Admiral Byng also arrived with seven ships. On the same day 600 volunteer horse and foot troops of Northumberland mustered on the Town Moor accompanied by many gentlemen of the county and marched to Newcastle where they were joyfully received. On 26 September General Lord Mark Kerr arrived from Berwick, examined the walls and towers of Newcastle and declared them to be in good condition. At the same time he ordered three machine batteries to be raised – one in The Close, another on the Quay and the third on Windmill Hills.

In early October the King sent word he had despatched eight regiments of foot to Newcastle from Holland. Almost 200 guns had been positioned to defend Newcastle,

Field Marshal George Wade (1673–1748). During his career he supervised the building of over 250 miles of roads and forty bridges. (Scottish National Portrait Gallery)

keels had been sent up the Tyne from Clifford's Fort with powder, ball and other armaments and 600 of La Rocque's Dutch Regiment arrived in Newcastle from Berwick. In the days afterwards those who resided without the walls were asked to deliver up their ladders and firearms to the Town's Yard so they could not be used by the rebels to assail the walls. Pickaxes or shovels were also to be deposited at the Mayor's House. Sentry boxes were set at convenient distances on the walls of Newcastle, a vast number of sandbags hung over them and pallisadoes were fixed near them to hinder the access of any enemy troops. Several places along the Tyne were also palisadoed to prevent the enemy crossing at low water. News of the great efforts being made to defend Newcastle against the rebel army is said to have reached the rebels and they diverted their course to proceed to England via Carlisle.

On 28 October Field Marshal Wade, Commander-in-Chief of the army intended for the north, arrived at Newcastle with a force of around 1,400 men and resolved to wait, not only to defend the coal mines but also to stand ready in case the town was attacked. The following day six Dutch regiments arrived in Newcastle with Prince Maurice of Nassau in command and together with Field Marshal Wade they encamped on the Town Moor.

Wade marched off his forces on 14 November for the relief of Carlisle but his troops were severely hampered marching across the terrain of Northumberland and arrived too late to prevent it falling into enemy hands. Wade and his troops returned to Newcastle after a journey where they suffered bitter cold and painful hunger. There was simply no road in existence that was suitable for marching troops or the movement of artillery from Newcastle to Dumfriesshire. Wade's bitter experience led him to plan and begin construction of his Military Road in 1746. The road (the B6318) still runs straight and true for miles alongside Hadrian's Wall from Heddon-on-the-Wall in the east to Greenhead in the west. Nothing was allowed to stand in the way of the road – even the Roman wall, which was seen as a useful source of hardcore rubble for the road bed.

The news the Duke of Cumberland had retaken Carlisle reached Newcastle on Old Year's Night 1745. The celebrations became bumper occasions and the bells of the town's churches rang all through night and the next morning. The final victory over the rebels at Culloden in April 1746 was described by local chronicler John Sykes in his *Historical Records* as the 'greatest rejoicings ever known in Newcastle'.

On 28 July 1746 leading Jacobite Simon Fraser, Lord Lovat, was brought to Newcastle from Scotland for an overnight stop. He was escorted to London under a strong military guard, not only to stop him from escaping but to fend off those who would harm the man before he faced trial. Lovat was found guilty of treason and was beheaded on Tower Hill.

7. The Napoleonic Wars

The outbreak of the French Revolution in 1789 and the execution four years later of Louis XVI by Revolutionists caused the end of British diplomatic relations with France and they declared war on Great Britain and Holland. Some of the young local men left labouring down the mines or on the land to answer the call of the recruiting sergeants, took the king's shilling and joined the army. The press gangs for the Royal Navy were also active. In one incident on 26 April 1793 the regiment at Tynemouth barracks was drawn out and formed into a cordon around North Shields to prevent any person from escaping and impressment gangs set out about the streets. By the following morning 250 men had been forced on-board armed vessels in Shields Harbour.

Early in 1794 Lord Lieutenants across the country were asked by king and government to raise corps of volunteer infantry and fencible cavalry for their defence of their localities as a precautionary measure in the event of invasion. Committees were set up to raise private subscriptions for the uniforms and equipment of local volunteer units. Over the years 1794–95 the Loyal Newcastle Volunteers (LNV) and the Loyal Berwick Volunteers were formed and raised four companies of soldiers. Under the command of Colonel Thomas Clennel the LNV increased to six companies in 1799 (420 men). They were predominantly recruited from the aristocratic class of the inhabitants and with their uniforms being colourful and embellished, they soon acquired the nickname of 'The Tinsel Dons'. There was also the Newcastle Upon Tyne Yeomanry Cavalry (1797) consisting of one troop under Capt. Miles Monkhouse.

The Armed Associations Act 1798 led to a proliferation of new units of volunteers that were to be emergency corps raised at local levels with the intention of creating trained units to defend their towns and city parishes in the event of an enemy invasion. The units formed in Northumberland between 1798 and 1805 were:

Berwick Gentleman Independent Volunteers (eighty nine men)
Berwick Volunteer Artillery (sixty-four men)
Bywell Volunteer Yeomanry Cavalry (seventy-five men)
Corbridge Volunteer Corps of Infantry (seventy men)
Coquetdale Ranger Troop of Volunteer Cavalry (fifty-five men)
Hexham Volunteer Infantry (140 men) (In 1808 the Hexham and Corbridge corps were united under Major Mark William Carr)
Loyal Glendale Rangers (raised in 1801), reformed in 1803 as the Glendale Volunteer Cavalry (fifty-two men) and the Glendale Volunteer Infantry (sixty-two men)
Newcastle Armed Association (1,314 men)
Morpeth Associated Corps of Volunteer Infantry (125 men)
North Shields and Tynemouth Volunteer Infantry (332 men)
Percy Tenantry Volunteers (including cavalry, infantry and artillery 1,511 men)

Royal Cheviot Legion Cavalry (124 men)
Royal Cheviot Legion Infantry (660 men)
Seaton Delaval Associated Corps of Volunteer Infantry (seventy men)
Slaley and Bywell St Andrew's Volunteer Infantry (139 men)
Wallington and Kirkharle Volunteer Troop of Cavalry (forty-two men)
Wallsend Volunteer Rifle Corps (145 men)

The Newcastle Associated Infantry commanded by Sir Matthew White Ridley received government funding and drew its men, for the most part, from the middle and lower classes.

The Royal Cheviot Legion under Lt-Col Horace St Paul enrolled its first members in 1799 and after its re-enrolment in 1803 had four troops of cavalry and ten infantry companies recruited from Wooler, Chillingham, Chatton, Doddington, Kirknewton, Ford, Brankstone, Lowick, Belford, Embleton, Alnwick, Warkworth, Felton, Ilderton and Eglingham.

The North Shields and Tynemouth Volunteer Infantry were raised by Major (later Colonel) William Linskill and had their headquarters at the Percy Square Barracks. There was regular training in drill and Sunday mornings were principle field days from 10.00 a.m. until 1.00 p.m. when they held manoeuvres on the Park Field of Tynemouth Lodge, under the supervision of the field officers of the regular forces stationed at Tynemouth, Percy Square or Chirton Barracks (later known as South Preston).

The largest unit of volunteers in the county were the Percy Tenantry Volunteers. Raised in 1798 by Hugh Percy, 2nd Duke of Northumberland, they rose to be 1,500 strong with all NCOs and privates clothed at the duke's expense and those who were paid received it from His Grace's private purse. Consisting of both cavalry and infantry, the muster roll of 1803 states there were troops of cavalry at Alnwick, Lesbury, Newham, Newburn, Prudhoe and Tynemouth with around fifty mounted troops in each. The infantry had companies of around seventy men in Alnwick, Chatton, Guyzance & Thurston, Lesbury, Longhoughton, Newham, Rothbury, Shilbottle, Warkworth, Barrasford (two companies), Lemington, Newburn (two companies), Prudhoe (two companies) and Tynemouth. A further Percy Tenantry Volunteer Artillery of around twenty-six men was formed in 1805.

A chain of warning beacons that could be ignited to signal the landing of invasion forces by the enemy were also erected along the high points of the coastline from around 1798. The beacons were located at such places as Seaton Sluice, Newbiggin, Hawksley Point and Dunstanburgh Castle. Organised by the Trustees for Guarding the Coast, also known as the Northumberland Coast Committee, they paid for the manufacture and erection of the beacons as well as providing signal flags, telescopes and fuel for them so that a code of signals could be established to alert troops around the county by day or night in case of need. They also arranged local stocks of gunpowder to be held for defending troops in the event of deployment.

Plans and preparations were also made for the evacuation of the vulnerable from Newcastle in the event of invasion. The eminent local lawyer Mr Hopper Williamson, who was unable to join the volunteers on account of his deafness, was given command of this 'flying column' of pre-identified carts to remove the women and children of the town to Alston Moor. On the evening of 1 February 1804 a false alarm was raised that the French

had landed at Bamburgh Sands. The beacon fires were lit and alarm bells rung. Of course no enemy came but it certainly demonstrated the volunteers were summoned and turned out in good time with no lack of zeal or ardour.

The invasion never emerged and the volunteers never got to grips with 'Frenchies' but the volunteers prepared well with regular drills, shooting practice and field exercises. The North Shields and Tynemouth Volunteers entered upon permanent duty as guards at Clifford's Fort, Tynemouth, for one month on 30 April 1804. The fort had not been in their possession for four hours when Major Doyle of the Light Brigade from Sunderland crossed the Tyne in a large flat-bottomed boat accompanied by one company of the 61st Regiment, one company of Northumberland Militia and one company of Lanark Militia. The major galloped up to the fort gate and demanded entrance but was refused by Colonel Linskill. Another company of volunteers was soon marching down from Dockwray Square and began a 'sharp sham action' on the Low Lights Bridge, while the men of the fort made a sally and the mock battle commenced. The engagement ended with the retreat of the assailants.

As the Napoleonic Wars drew to a close just after the first decade of the nineteenth century, due to the mixture of personalities and the radical politics some of the local nobility who had raised local units across Northumberland caused concern in government circles and the smaller units were encouraged to merge into one of the three larger local militia battalions. In 1814 these were recorded as:

The Northern Regiment of Local Militia commanded by Lt Colonel Horace St Paul (ten companies, 761 men) Headquarters: Alnwick

The Western Regiment of Local Militia commanded by Lt Colonel Thomas Wentowrth Beaumont (ten companies, 788 men) Headquarters: Hexham

The Southern Regiment of Local Militia commanded by Colonel Charles William Bigge (ten companies 765 men). Headquarters: Morpeth.

The exile of Napoleon to Elba removed the fear of invasion and as men were transferred to the local militia units the majority of the Northumbrian volunteer units were stood down and their colours laid up from 1813 to 1814 and their arms were returned into store after final defeat of Napoleon at Waterloo the following year.

Yeomanry units like the Coquetdale Rangers also clung on for a few years afterwards; indeed there was a resurgence in 1819 when the revolutionary spirit that pervaded in the North at the time caused instances of riots and crime broke out to the degree that the Lord Lieutenant called in a general meeting of magistrates of the county in October 1819 to consider the best means of rendering effectual aid to the civil power in case of disturbance. As a result a cohort of special constables were sworn in and it was recommended Armed Associations be raised in urban areas to preserve property and the public peace. Out of this came the Northumberland and Newcastle Volunteer Corps of Cavalry formed in December 1819, which consisted of six troops of approximately fifty men. Under the command of Charles John Brandling, Esq. of Gosforth, its officers and ranks were made up of gentlemen and upstanding tradesmen, merchants of colliery officials. Their function,

in the days before a national police force, was to deal with any local instance of riot, civil disturbance or strikes. Their presence was made all the more formidable from 1820 when twenty men in each troop were to train and serve as dismounted light infantry armed with carbines, which continued in the corps until 1876.

The Percy Tenantry Volunteer Artillery also carried on. Their three pounder guns provided by the government were returned and the Duke of Northumberland replaced them with six pounders. Revitalised in the 1850s, the unit became 2nd Northumberland (Percy) Artillery, which was finally disbanded in 1902.

Barracks

Up until the late seventeenth century Britain's armies were raised when they were required. It was only after the Restoration that a standing army of full-time professional soldiers was raised in the 1660s. Among the first of these was the Coldstream Guards founded by General George Monck at Coldstream in 1650 as part of the New Model Army, the regiment contained men from the Borders, Berwickshire and Northumberland. Swearing allegiance to Charles II in 1660, it was one of the founding regiments of the modern standing army. Today it is the oldest regiment in continuous service in the Regular Army and still finds many of its recruits from the men of the North.

One of the greatest problems to confront the newly raised regiments of the standing army was accommodation. Historically, soldiers had been billeted in households and in

Early nineteenth-century poster for the supply of hammocks for soldiers due to be billeted in Morpeth.

taverns, which was hardly a good idea when drunkenness was a persistent problem in the army. Tented camps were a temporary solution and were commonly used when on campaign abroad, but they had their own problems of security, comfort, vulnerability to attack and the vagaries of the British weather.

Through the eighteenth and nineteenth centuries British cities and large towns were keen to have military units with permanent barracks in their bounds, although they were often mindful not to have them too central – as eloquently put by Kipling 'Tommy' was only truly welcome when the 'drums begin to roll' in times of conflict. Barracks contained and controlled the soldiers in one place, the garrison would give the place a feeling of security and if there were incidents of protest and riot, in those days before a formal police force, it reassured city fathers to have troops on your doorstep to quell such situations. With centuries of strife on the English-Scottish border it is not surprising one of the country's first barracks was built in Berwick.

Berwick

The Barracks at Berwick, (known as Ravensdowne Barracks from the 1920s) were begun in 1717 as a direct response to the Jacobite rising of 1715. Designed by Nicholas Hawksmoor and built just inside the Elizabethan fortifications of the town, the construction was managed by the Board of Ordnance under the supervision of Captain Thomas Phillips. The first regiment, Colonel Kerr's 2nd Foot (later the Queen's Royal Regiment (West Surrey) took up residence at the barracks in 1721 when it was capable of accommodating 600 men and 36 officers. The Clock Block was built in 1739–41 and a military hospital was built a short distance from the barracks in 1745.

After the Napoleonic Wars ended in 1815 the barracks were vacated until the 1850s when the army occupied them again. The Childers Reforms for the Army in the 1880s,

Engraving of The Barracks, Berwick, in the late eighteenth century.

Above: Parade ground of The Barracks, Berwick, in the early twentieth century, depot of the King's Own Scottish Borderers.

Below: Postcard showing the uniforms, battle honours and history of the King's Own Scottish Borderers from the famous Gale & Polden *British Army History and Traditions* series, c. 1908.

THE KING'S OWN SCOTTISH BORDERERS.
(25th Foot.)
BATTLE HONOURS.
The Castle of Edinburgh, with the motto, "*Nisi Dominus frustra.*"

In the first and fourth corners the Royal Crest with the motto, "*In Veritate Religionis confido.*" In the second and third corners the White Horse, with "*Nec aspera terrent.*"

The Sphinx, superscribed "Egypt."

"Namur, 1695." "Afghanistan, 1878-80."
"Minden." "Chitral," "Tirah."
"Egmont-op-Zee." "South Africa, 1900-02."
"Martinique, 1809." "Paardeberg."

HISTORY AND TRADITIONS.
The regiment was formed in 1689. Proceeding to Flanders it was present at the battles of Steinkirk and Landen, and the siege of Namur. In 1727-8 it shared in the defence at Gibraltar. It took part in the battle of Fontenoy in 1745, and in the following year in the historic battle of Minden. It was engaged in the defence of Gibraltar, 1782; and, acting as Marines participated in Lord Howe's glorious victory of 1st June, 1794. It distinguished itself at Egmont-op-Zee in 1799, and in Egypt in 1801. It served in the Afghan War 1878-80, the Suakim Campaign 1888, Chitral 1895, and Tirah 1897. During the South African War it took part in the battles leading up to the capture of Pretoria, and shared in the hardships of the campaign to the conclusion of the war.

NOTE.—This regiment has the exclusive privilege of beating up for recruits in the streets of Edinburgh at any time without asking leave of the Lord Provost.

when numbered regiments were abolished and they became regiments affiliated to counties, usually their old regimental recruiting district, saw Berwick become the Depot of the King's Own Borderers in 1881 (styled King's Own Scottish Borderers in 1887) until the regiment moved out of the barracks in 1963. Used for a few years afterward by the Territorial Army, today it is in the hands of English Heritage and includes the Regimental Museum of the King's Own Scottish Borderers.

Royal Field Artillery on parade, Newcastle Barracks Square, *c.* 1880

Fenham Barracks

Newcastle Barracks (officially known as Fenham Barracks from the 1920s) was designed by James Johnson and John Sanders, architects who designed many British barracks in the early nineteenth century. Work began in 1804 and the first regiment, the North British Dragoons (Scots Greys), took up residence in 1806, closely followed by the 6th (Inniskilling) Dragoon Guards. When completed the barracks could accommodate one field officer, three captains, six subalterns, 264 soldiers and had stables for 294 horses. The barracks was then almost continuously occupied by a variety of military units until the 1990s. Up to the late 1870s there was a variety of both cavalry and line infantry regiments. In 1881 the Northumberland Fusiliers set up their depot at Newcastle Barracks and were joined by the Durham Light Infantry, who also made the Barracks their regimental depot in 1883 until they moved to Brancepeth in 1939.

The Royal Northumberland Fusiliers were absorbed into the Royal Regiment of Fusiliers in 1962. Links with the barracks lingered for a few years afterwards but the museum moved out to Alnwick Castle in 1970 and most of the Georgian barrack buildings were demolished and replaced with new buildings for military purposes. The new barracks remain home to a number of Army Reserve units.

Tynemouth Castle, the Spanish Battery and Clifford's Fort

The mouth of the Tyne has been seen as an important 'gateway' to England for centuries and thus required a military presence to defend it from both privateers and enemy incursions.

Tynemouth Priory and artillerymen, *c.* 1830.

Some of the earliest recorded date back to the fourteenth century when defensive measures were taken at Tynemouth Monastery after the Battle of Bannockburn in 1314 and the prior paid for a garrison of eighty men. When Henry VIII's commissioners took over in 1539 the priory buildings were fortified and turned over entirely for the defence of the Tyne. A great curtain wall had been built, a ditch was excavated and flanking positions were constructed. A further artillery position, later known as the Spanish Battery, was created on the lower headland in 1545 to protect Henry VIII's fleet as it assembled on the Tyne before embarking for Scotland. At the time of the first Dutch War (1652–54) the garrison consisted of a master gunner, twenty gunners, seven guns and a detachment of foot soldiers.

Clifford's Fort, designed by Swedish engineer Martin Beckman, was built a short distance upriver in North Shields in 1672. It was built to defend the entrance of the Tyne from naval attack during the Third Anglo-Dutch War (1672–74) and would provide the main defence for the river during the seventeenth century.

In the 1780s Captain Elias Durnford adapted the Tynemouth Castle gatehouse to become a barracks and a detachment from the Royal Artillery maintained the guns. At the time of the Napoleonic Wars the Tynemouth batteries had increased to a formidable thirty-two 18-pounder guns, eight 12-pounders and eleven 9-pounders.

In the nineteenth century the Tyne was not only the centre of the British Empire's coal trade but had become dotted by battleship builders and armament manufacturers. The Tynemouth defences also kept pace, transforming into a modern coastal fortress in the late 1880s and early 1890s. A submarine minefield was created to protect the mouth of the river. In 1895 the first searchlight to be used on the Tyne was installed at Clifford's Fort for the illumination of the minefield. By 1905 the headland was totally re-equipped with all modern artillery consisting of two 6-inch guns, two 12-pounder quick firing (Q.F.) guns and one mighty 9.2-inch gun. The Spanish Battery was also refitted with two 6-inch and two 12-pounder Q.F. guns. Together the defences now had both long- and close-range firepower.

The Spanish Battery 1886, engraving from a drawing by C. J. Spence showing it as it was the year before it was rebuilt.

The Spanish Battery showing its new walls under construction, 1887.

By the beginning of the First World War the headland had become the centre of a large and integrated Fire Command that controlled gun positions along the coast from Blyth to Sunderland. During the Second World War Fire Command was reactivated and had one 9.2-inch breach loading (B.L.) gun for counter-bombardment defence and two close-range 6-inch guns. Initially manned by Royal Artillery gunners, the Tynemouth battery positions were taken over late in the war by the Home Guard after the immediate

danger of invasion had passed. In 1943 the Spanish Battery was stood down and in 1944 Clifford's Fort's operational role ceased.

In the years after the war the Tynemouth guns were manned by the Territorial Army. The Spanish Battery was dismantled in 1954, coast artillery was disbanded as a whole in 1956 and the guns of the Tynemouth defences were scrapped.

The majority of the old Tynemouth military buildings, parts of which dated back to the seventeenth century including the governor's house and barracks, were demolished in 1960. Today the coastal battery, magazines and medieval priory are in the care of English Heritage.

Troops and the castle yard, Tynemouth Castle, *c.* 1890. The lighthouse rear left was demolished in 1898–99 and the barracks, governor's house (left) and ammunition magazine (right) around the priory ruins were all demolished in 1960.

9. The Victorian and Edwardian Eras

In retrospect the reigns of Queen Victoria (1837–1901) and Edward VII (1901–10) are marked by colonial wars fought all over the world that expanded the British Empire, but Britain itself experienced a long period of peace without major internal strife or rebellion. There were, however, periods when foreign rumblings provoked fears of attack or invasion. Such was the situation in the 1850s when the machinations of France ('The Old Enemy') caused enough consternation in the Palmerston government for Sydney Herbert, the Secretary of War acting under the Volunteer Act of 1804, to issue a circular in 1859 to the Lord Lieutenants of counties authorising them to accept the services of any companies of volunteers that set in motion new age of volunteer soldiering in Britain.

Aware of its long strategically important position, among the first to answer the call was Tynemouth where at a meeting held in the Albion Hotel in April 1859, it was resolved to offer the services of both a volunteer rifle and artillery corps to the Lord Lieutenant. Both units were raised and the first general drill of the corps was held on 25 May 1859 at the George Tavern. (The Tynemouth Volunteer Artillery has a good claim to be the oldest volunteer artillery unit in the British Army.) Further artillery volunteers soon followed in Berwick, Newcastle and the old Percy Artillery was regenerated as the 2nd Northumberland (Percy) Artillery. A corps of engineer volunteers was also raised from the men of Armstrong's factory at Elswick in 1860.

Companies of rifle volunteers also sprung up across Northumberland and by 1861 there were corps in Newcastle, Walker, North Shields, Tynemouth, Berwick, Alnwick, Hexham, Morpeth, Belford, Bellingham, Allendale, Lowick, St John Lee, Sandhoe, Corbridge and Haltwhistle.

In 1872 jurisdiction over the volunteers was removed from county Lord Lieutenants and placed under the Secretary of State for War and the volunteers became far more integrated within the structure of the army. Times were changing. In 1876 the Newcastle Corps of Cavalry was renamed the Northumberland Hussars. In 1879 the War Office decided to unite all smaller artillery corps of Northumberland and Durham under one consolidated command. When this scheme was carried out the 3rd Northumberland (Newcastle) and the 1st Durham (Sunderland) were amalgamated with 1st Northumberland (Tynemouth) and took its name and precedence. It was to be a short-lived consolidation as the Tynemouth corps soon grew and became a distinct regiment again with a fifth battery formed at Tynemouth, a sixth at Backworth and a further two batteries at Blyth.

In 1881 the Childers Reforms created a rolling plan whereby rifle volunteer corps would become the new volunteer battalions of their county regiments and consequently the rifle companies of the county consolidated to create the new 1st, 2nd and 3rd Volunteer Battalions of the Northumberland Fusiliers in 1887. A new unit, the Tyne Division Engineers (Volunteers) Submarine Miners (later becoming the Tyne Electrical Engineers),

Above left: Northumberland Hussars and members of the Northumberland and Durham Imperial Yeomanry parade outside St Nicholas Cathedral ready to attend the Thanksgiving Service to celebrate their return from the South African War on 10 August 1901.

Above right: A member of 1st Volunteer Battalion, Northumberland Fusiliers, on 'sentry go', *c.* 1899. Instead of the usual red the tunics worn by the majority of British line infantry regiments the Northumberland Volunteer Battalions wore grey in remembrance of their origins as rifle volunteers.

Right: A member of the 1st Volunteer Battalion, Northumberland Fusiliers, in the slouch that became the standard wear for British troops during the South African War pictured in 1903.

The memorial to Lt-Col George Elliott Benson, Royal Artillery, by sculptor John Tweed, was erected by public subscription in Hexham and is seen here shortly after it was unveiled by General Lord Methuen on 9 March 1904. Benson had been killed in action while in command of his column at the Battle of Brakenlaagte during the South African War on 30 October 1901.

was raised in 1888 to create and maintain a submarine minefield at the mouth of the Tyne and were based at Clifford's Fort, North Shields.

The volunteers began to shape up, trained together and competed together and with other units at sports. When the call came for volunteers for Queen Victoria's largest war, the Anglo-Boer War (1899–1902), the volunteers did their bit sending volunteer companies for one year's service in the field. Some 355 men from the Northumberland Hussars and volunteers from Northumberland and Durham saw service in the 14th, 15th and 55th squadrons of the Imperial Yeomanry, who also served in South Africa.

In January 1900 Armstrong Whitworth Ltd received an order from brewery heiress Lady Mieux for six 3-inch Q.F. naval guns mounted on field carriages and which she donated to Lord Roberts, Commander-in-Chief of British Force in South Africa. They became his personal property, which he deployed wisely and well throughout the campaign. The men who operated the guns were no strangers to them for they were manned by the 244 officers and men of the 1st Northumberland Royal Garrison Artillery Volunteers, a unit raised for active service at the Drill Hall near the works; hence they were known as the 'Elswick Battery'.

The impressive 24-metre-high South African War Memorial in the Haymarket, Newcastle, built in 1908 remembers the 370 soldiers of Northumbrian regiments that fell in the conflict.

The face of the Tyne changed beyond all recognition in the latter half of the nineteenth century. Not only did it benefit from all the new technology the industrial age could bring, but coal from the collieries of the north that fuelled the country and industry around the

Above: Plan of the Tyne from Elswick to the sea showing the shipyards and marine engineers along its length, 1904.

Below left: The South African War Memorial on the Haymarket, Newcastle, unveiled by Lt-Gen Sir Laurence Oliphant, Commander-in-Chief, Northern Command, on 22 June 1908 remembers the 370 soldiers of Northumbrian regiments that fell in that conflict.

Below right: Menu for the banquet to the vice admiral, rear admiral, captains and officers of the Channel Fleet held at the Old Assembly Rooms when the fleet visited Newcastle in September 1904.

world steamed out from its waters in millions of tonnes every year. A third of Britain's navy, and battleships supplied to other navies around the world, were built in the mighty shipyards of the Tyne such as Palmers of Jarrow, Swan, Hunter & Wigham Richardson and the Wallsend Slipway and Engineering Co. The greatest manufacturer of battleships and armaments of them all was Armstrong Whitworth & Co. whose Elswick Works had a 72-acre site that extended more than a mile along the north bank of the Tyne.

Above: Riverside view of the Elswick Works of Armstrong Whitworth & Co., *c.* 1900, whose 72-acre site extended more than a mile along the north bank of the Tyne.

Below: Launch of the battlecruiser HMS *Invincible* from Elswick, 13 April 1907. She was sunk at the Battle of Jutland, 31 May 1916. (Newcastle Library)

The training ship *Wellesley* in Tynemouth Harbour where boys deemed as destitute or suffering parental neglect were given shelter and an education that would equip them for a life at sea.

HMS *Dreadnought*, the first all iron-clad, all big gun, turbine-driven battleship was not built on the Tyne but the implications of a battleship that outclassed all other ships in the world at the time saw the genesis of a navy 'race' between Britain and Germany, which saw unprecedented numbers of battleships, cruisers and new fighting vessels for the Royal Navy built on the Tyne.

For the army it was also a time of dramatic change. Lessons learned in the South Africa led to the Haldane Reforms. The most significant of these was the complete reorganisation of the Home Field Army and Reserve System. Under this scheme most line infantry regiments would have two regular battalions. One would provide garrison troops across the British Empire (in the case of the Northumberland Fusiliers there were foreign stations in India) while the other battalion would be based in Britain and Ireland on 'Home Service' and could be mobilized at short notice to form a British Expeditionary Force (B.E.F.) in the event of a war emergency. There was also an Army Reserve and a Special Reserve, most common of which were soldiers who had served their time but were held on record for five years as a reservist. Haldane also got rid of the old volunteer system in favour of a new Territorial Force of part-time soldiers who would train to defend the home territory in the event of a 'war emergency,' taking the place of the regular battalions that would have been sent to Europe as a B.E.F.

The Territorial Force was not created with any intention that it would be deployed abroad on active service. One of the new battalions granted to the Northumberland Fusiliers in 1908 was one of the eleven much-vaunted cyclist battalions. The four

Thousands line the route to watch as one of the first parades of the new Territorial Force makes its way from Barras Bridge to the Haymarket, Newcastle, 3 April 1909.

Northumberland Territorial Force Battalions rapidly came up to strength and formed their own brigade and the 8th (Cyclist) Battalion (T. F.) became an entity in its own right as the Northern Cyclist Battalion in 1910.

The post-1908 reformed battalions of the Northumberland Fusiliers were as follows:

1st Battalion (Regular Army)
2nd Battalion (Regular Army)
3rd Battalion (Special Reserve)
4th Battalion (T. F.) (HQ: Hencotes, Hexham)
5th Battalion (T. F.) (HQ: Church Street, Walker)
6th (City) Battalion (T. F.) (HQ: Northumberland Road, Newcastle)
7th Battalion (T. F.) (HQ: Fenkle Street, Alnwick)
8th (Cyclist) Battalion (HQ: Hutton Terrace in Newcastle) (later The Northern Cyclists)

There were also the Northumberland Hussars and T. F. corps in the form of Royal Field Artillery, Royal Army Medical Corps, Royal Engineers, Tynemouth Royal Garrison Artillery and Tyne Electrical Engineers.

The clouds of war drew in slowly but surely throughout the first decade of the twentieth century for many in government and military circles it was not a matter of if there was going to be a war, but when. As early as 1909 Coastal Defence Commanders like Colonel W. Russell, Coast Defence Commander, North Eastern Coast Defences, liaised with their county Lord Lieutenants and civil leaders in positions of responsibility to set plans of action of how to inform the correct authorities that an enemy had made a successful landing.

Above: Members of the 1st Northumbrian Royal Engineers (T. F.) practising bayonet fencing at Summer Camp, *c.* 1910.

Below: Transport Section, 1st Northumbrian Royal Engineers, at camp, 1910.

The 7th Battalion, Northumberland Fusiliers (T. F.), Coronation Party, ready to depart from Haltwhistle for London, 1911.

Local Territorials and members of the Boys Brigade on parade in Morpeth for the celebration of the Coronation of HM George V in June 1911.

Soldiers of 4th Battalion, Northumberland Fusiliers (T. F.), marching to summer camp at Richmond, Yorkshire, 1910.

The smart tent lines of the Northumberland Fusiliers Terrritorial Force Infantry Brigade Camp at Richmond, Yorkshire, 1910.

A smart group of soldiers from 7th Battalion, Northumberland Fusiliers (T. F.), before their church parade at camp at Richmond, Yorkshire, 1910.

Squadron parade of the Northumberland Hussars at camp at Rothbury, 1910.

Above: Sergeants of 6th (City of Newcastle) Battalion, Northumberland Fusiliers, at Territorial Brigade summer camp, Bridlington, Yorkshire, 1913.

Below: Sappers of 1st Northumbrian Royal Engineers digging trenches at Territorial Brigade summer camp at Greystoke near Penrith, Cumbria, 1914.

The key to dealing with such a situation was the mobilisation of local troops and the safe evacuation of the civil population using roads or routes that would not impede any military forces arriving in the area. If the situation escalated this could also mean drafting in extra troops who would not be as familiar with the locality so in 1912 the Army Council sanctioned County Territorial Force Associations to raise Corps of Guides as part of the Technical Reserve of the T. F. The corps was to be made up of men who possessed an intimate knowledge of their local areas: the bridges, road and paths, as well as water supplies, blacksmiths and wheelwrights that would make very useful knowledge for incoming troops. Military training was not essential as the guides were not expected to be armed and they were issued with a badge supplied by the War Office to show they were working with their authority and not spies.

Lapel badge issued to members of the Northumberland Corps of Guides by the War Office.

10. The First and the Second World Wars

When the First World War broke out on 4 August 1914 the military of Northumberland stood ready. The special service section of a number of Territorial battalions were already on duty at key points along the coast: 200 Grenadier Guards were immediately despatched from London to take post guarding bridges, gasworks and other vulnerable places in Newcastle, and the searchlights of the Tyne Electrical Engineers were already shining out over the sea watching for enemy vessels days before war was declared.

Royal Navy reservists were mobilized on 3 August, Army Reserves on 4th and Territorials reported for duty at their headquarters on 5 August 1915.

Lord Kitchener, the newly appointed Secretary of State for War, predicted the war was not going to be over by Christmas; indeed he believed the country should prepare itself for at least a period of three years of conflict that would require some seventy divisions to fight it. Kitchener presented his request to raise an army of 500,000 men to Parliament. His request was granted by return and the first adverts appealing for his first 100,000 men started to appear in newspapers and on posters soon afterwards.

One of the Northumberland Fusiliers Territorial Battalion's Maxim Gun Sections when encamped on Gosforth Park, September 1914.

Above: Members of the Northumberland Hussars, 1914. Many of them wear the Imperial Service badge that signifies they had volunteered for overseas service; indeed so many had done so, and so quickly, that the unit was one of the few yeomanry squadrons to proceed on active service to France in 1914.

Left: The Northumberland Hussars were most certainly ready in 1914!

The Northumberland Hussars are Ready !

Above: Fifeshire Royal Field Artillery Battery (T. F.) on manoeuvres across the countryside around Redesdale, 1914.

Below: The camp at Redesdale, pictured *c.* 1914, provided tented accommodation for soldiers and canvas stables for horses. The camp was surrounded by acres of land owned by the government, terrain that was comparable with France and Flanders and a firing range that was ideal for the artillery units that trained there.

Above: Hareshaw Common Artillery Camp, *c.* 1914. A further training camp was established on Hareshaw Common, just outside Bellingham, in 1914. With so many new recruits joining the Royal Field Artillery, prospective gunners would spend their first week of basic training in the field at Hareshaw before going to Redesdale Camp.

Below: Lads of the 2nd Battery, City of Aberdeen Royal Field Artillery (T. F.), while in training at Redesdale Camp, September 1914.

Above left: Greetings postcard from the army camp at Cramlington, 1914. Rows of white bell tents creating temporary army camps for mobilized troops in training and on anti-invasion patrol duties sprung up all over the county in the early years of the First World War.

Above right: One of many versions of the image of Kitchener, his pointing finger and the appeal to YOU to join up.

Below: Local lads leaving to join their unit having been accepted as recruits, 1914. In their hands are their brown paper parcels tied up with string containing two shirts, underwear and two pairs of socks.

Your King and Country Need You.

A CALL TO ARMS.

An addition of 100,000 men to his Majesty's Regular Army is immediately necessary in the present grave National Emergency.

Lord Kitchener is confident that this appeal will be at once responded to by all those who have the safety of our Empire at heart.

TERMS OF SERVICE.

General Service for a period of 3 years or until the war is concluded.

Age of Enlistment between 19 and 30.

HOW TO JOIN.

Full information can be obtained at any Post Office in the Kingdom or at any Military depot.

GOD SAVE THE KING!

Left: The original recruiting poster for Kitchener's Army published in August 1914.

Below: Kitchener recruits in the Blandford Street Dining Hall (now the Discovery Museum), Newcastle, 1914.

Blandford Street Dining Hall, Newcastle-on-Tyne, KITCHENER'S RECRUITS.

Above: Officers, senior NCOs, instructors and depot staff of the Northumberland Fusiliers at Fenham Barracks, Newcastle, *c*. 1915.

Right: One of the Ashington lads serving in Hawke Battalion, Royal Naval Division (RND). It's often forgotten that many Northumberland boys joined or were transferred to the RND during the First World War. It was an unusual unit that deployed Royal Navy and Royal Marine reservists and volunteers that were not needed for service at sea to fight on land. The RND had eight battalions, each one named after a distinguished naval commander: Drake, Benbow, Hawke, Collingwood, Nelson, Howe, Hood and Anson.

No other British city outside London raised more battalions of soldiers for Kitchener's Army than Newcastle (eighteen battalions were raised in the city). Some 1,100 men enlisted in the city in the first eleven days of the campaign to raise the 'New Army' and Newcastle that can proudly claim it raised the very first battalion of any English regiment in Kitchener's Army (registered complete 21 August 1914). This unit became 8th (Service) Battalion, Northumberland Fusiliers. Thousands of volunteers from all walks of life would follow their example and Geordie lads could be found serving in the Royal Navy, Flying Corps and just about every regiment and corps of the Army during the First World War.

Fearful of invasion, local men too old to serve in the military or in war reserved occupations gathered themselves into armed bands such as the Newcastle Citizens

Training League to train to defend their local areas. This made the authorities uncomfortable so a national Volunteer Training Corps was formed to give the groups some affiliation and organisation. Led by local men of good standing, they were a forerunner of the Home Guard of the Second World War. The Newcastle VTC grew to exceed 2,000 members.

Fortunately Northumberland did not suffer bombardments from German naval vessels like its neighbouring counties did during war but it was bombed by Zeppelin raiders aiming for collieries, shipyards and munitions works on 14 April 1915, 15/16 June 1915, 2/3 April 1916, 2/3 May 1916 and 8/9 August 1916.

Everyone soon had something to do for the war effort it was the patriotic thing to do. Before and immediately after the outbreak of war hundreds of women had joined Voluntary Aid Detachments of the British Red Cross Society and St John Ambulance to train as volunteer nurses. There were sixty-five VA Detachments in Northumberland and Durham in 1914 and they were soon setting up and staffing many auxiliary war hospitals for returned wounded and sick soldiers that opened in country houses and public buildings across the county and helping in the county war hospitals. The first ambulance train carrying eleven wounded soldiers arrived at Newcastle station from Southampton on 15 September 1914.

Women also ran fundraising collections and events for war charities. Working parties were set up to make comforts such as scarves, socks and balaclavas for soldiers and sailors on active service, to send parcels to prisoners of war and the Elswick & Scotswood Bandage Party made and supplied thousands of bandages to war hospitals both at home and abroad. As more and more men left to serve at the front and the factories and shipyards of Newcastle expanded to produce more munitions for the war effort, unprecedented numbers of women joined the workforce. There were also a hearty number that joined the ranks of the Women's Volunteer Reserve and women's branches of all three military services when they were created later in the war.

Officers of the Northumberland Volunteers, 1918. Originally formed as a Volunteer Training Corps to provide a local fighting force during the invasion scares of 1914, its ranks consisted of men too old for military service or for war reserved occupations. In many ways they were a precursor to the Home Guard of the Second World War.

Crater left by a high-explosive bomb in a field near Bedlington after the first Zeppelin air raid on Northumberland on 14 April 1915.

Ward A6 at the 1st Northern General Hospital, Armstrong College, Newcastle, 1915.

Two Queen Alexandra's Imperial Military Nursing Service Reserve nurses (centre) flanked by four St John Ambulance VAD nurses with returned wounded and sick soldiers and airmen at the Northumberland War Hospital, Gosforth, 1918.

Women and children street collectors from Walker raising funds under the banner of 'Remember Jack' for servicemen in the Royal Navy on Sailors Day, 1915.

The wartime staff of George F. Laybourne & Co. Printers, Collingwood Yard, Groat Market, Newcastle, 1915. Women joined the workforce like never before to take the place of men who had left to serve their King and country.

Two male managers and women 'munitionettes' from the Elswick Munitions Works, Newcastle, 1916.

Above: George V and Queen Mary being shown a ship under repair at a Tyneside shipyard, June 1917.

Below left: Munitions worker lapel badge: On His Majesty's Service – Wallsend Slipway & Engineering Co. Ltd. This badge would show why the wearer was not in khaki to anyone who may have asked 'Why are you not doing your bit?'

Below right: Every city, town and village had welcome home committees and gave the returned servicemen return dinners, many of them presenting the local men with certificates of thanks or even watch fobs like this one from Ashington.

Above: The Peace Day procession, Ashington, 1919. The Armistice came on 11 November 1918 but most of those serving were still away on foreign shores, so to allow the demob process and to ensure the victory had been stabilised men were released from military service in groups and Peace Day was celebrated in Britain in July 1919.

Below left: Commemorative certificate presented to Jack Allan of Alnwick, who served in France and Flanders with 7th Battalion, Northumberland Fusiliers (T. F.).

Below right: The Newcastle War Memorial in Old Eldon Square was unveiled in front of a crowd of thousands by Field Marshal Earl Haig in 1923. It bears the poignant legend 'Memory Lingers Here'.

The unveiling of the Coldstream War Memorial by Field Marshal Earl Haig in May 1923. The occasion was attended by hundreds of local people and veterans of the war, and an Honour Guard was provided by a detachment of 4th Battalion, the King's Own Scottish Borderers.

Interwar Years

The Territorial Force was disbanded in the immediate aftermath of the First World War but was raised anew soon after. New recruiting began in early 1920. The Territorial Force was reconstituted on 7 February 1920, and on 1 October 1920 the Territorial Force was renamed the Territorial Army. Headquarters of the TA battalions of the Northumberland Fusiliers were as follows:

4th Battalion (Hexham)
5th Battalion (Walker)
6th Battalion (the City Battalion) St George's Drill Hall, Newcastle
7th Battalion (Hexham)

Throughout the 1920s and 1930s the training structure was similar to the pre-First World War years in that the recruit was put through his paces in drill and rifle but with the addition of new weaponry such as machine guns and up-to-date mortars. For the officers, especially those in the Northumberland Hussars it felt like being a member of a good club. Many of the old soldiers looking back in this time recalled a golden age of summer camps, sporting events, parades and military tournaments – 'peace time soldiering at its best' – and happy memories that they could call on in the darkest times of the war.

The camp and firing range at Redesdale that had been set up for training troops during the First World War expanded as the Army acquired more land and began testing light tanks and training soldiers how to operate them. Heavy tanks were found unsuitable because then sank in the soft ground. The whole area is now incorporated in the Otterburn Army Training Estate.

Above: A smart platoon of soldiers from one of the Territorial Army battalions of the Northumberland Fusiliers, *c.* 1930. Old soldiers would look back on the 1930s as a golden age of Territorial soldiering.

Below: Troopers of the Northumberland Hussars 'The Noodles' heading off to summer camp in the 1930s.

All potential recruits were advised upon joining that the TA provided a field force to supplement the Regular Army *either* in defence of this country or the defence of British interests abroad. No longer would a TA soldier be asked if he would *volunteer* for active service abroad; when you enlisted as a TA soldier it was part of your obligation.

Full expansion of the TA was only ordered on the eve of war on 2 March 1939 when it was announced that the size of the TA was to be doubled. The total strength of the TA was to be 440,000 and the field force of the Territorial Army was to rise from 130,000 to 340,000. With these sort of figures in mind, for many TA officers this late expansion was deplorable and really should have been addressed in the mid-1930s when the Nazis began to militarise the German people and rebuild their armed forces on an ever-growing scale.

Above: A multiview postcard of the Redesdale Artillery Camp, *c.* 1930.

Left: Recruits for the Tyne Electrical Engineers marching to St Thomas's Church, Newcastle, May 1939.

The various military commands around the UK staged many pageants and tattoos during the 1920s and 1930s. This programme was for the Northern Command Tattoo of 1934 that featured contributions from both the Durham Light Infantry and the Northumberland Fusiliers.

The Second World War

War broke out again on 3 September 1939 and once again Northumberland became a front-line county. Some 31,222 children were evacuated away from the densely population areas of Newcastle for fear of air raids on the shipyards and munitions factories along the Tyne. Some were removed to North Yorkshire, Cumberland and further afield, while others were not removed too far away, to places such as Wooler or Norham but for many kids this seemed a long, long way away from those they knew and loved. Others were taken to the coast only to be re-evacuated to inland rural locations when fears of invasion became very real after the fall of France in June 1940.

The harbours of Northumberland were all places the enemy could potentially make a landing. The number of gun positions along the coast were increased and all manner of pillboxes, anti-tank obstacles and fixed defences were strung out along the coastline and inland stop lines and at defensive points such as bridges and key roads. The request for Local Defence Volunteers ultimately resulted on the creation of eighteen Home Guard battalions who stood ready to give their all if there had been an invasion.

Thousands of local men and women served in the armed services all over the world during the war. There were certainly pre-war regular soldiers and local Territorials who were mobilised. There were plenty of those who volunteered but there were also many did not have any choice because conscription was introduced from 1939.

Evacuee children from Newcastle arriving at the Archbold Hall, Wooler, 1 September 1939.

Anti-tank blocks on the Beal end of the causeway from Holy Island. Originally put down in 1940 to stop or frustrate any attempt of invasion, they are still there today.

West Sleekburn Home Guard Platoon pictured at their stand-down in 1944.

Some of the men of the Tyne Electrical Engineers R. E. outside their headquarters at Debdon Gardens Drill Hall, Heaton, 1942.

Above: Royal Artillery Corps of Drums from Debdon Gardens Drill Hall, Heaton, 1941.

Below: Sandy Lane NAAFI, Newcastle, set up for a concert for the forces, 1941.

The munitions factories and shipyards along the Tyne were, as in the First World War, feared to be targets and in anticipation of enemy air raids mobile and fixed anti-aircraft, searchlight and barrage balloons were put in place. There was also a well-supported Air Raid Precautions scheme of wardens, rescue parties, aid posts, ambulance crews and welfare workers.

Enemy aircraft were on mine laying missions off the coast of Northumberland from 1939, but the first major raid took place in broad daylight on 2 July 1940 when a German bomber trying to hit the Tyne High Level Bridge hit the Spiller's factory.

Raiders came again and again over the county. In Newcastle alone there were 141 people killed and 587 injured in the air raids during the Second World War. Across the county there were more deaths; one of the worst losses in the entire North-East occurred on 3 May 1941 when 103 people were killed when a direct hit on Wilkinson's lemonade factory caused heavy machinery to collapse onto the shelter below.

After the success of the Normandy landings and successful advances into North Western Europe the Home Guard were stood down in the last months of 1944. Victory in Europe in May and victory over Japan in September 1945 heralded the end of the Second World War. There were great celebrations, but just like the First World War not that many years before, they were tinged with sadness because when while many families were reunited with loved ones returned from the services, there were many families who never saw their dads, sons or brothers again.

Women's Auxiliary Air Force Barrage Balloon Section, Park View, Heaton, 1941.

ARP Ambulance Section drivers and attendants, Wharrier Street, Walker, 1941.

Members of Newcastle Civil Defence at Cragside, November, 1944.

The band of the Northumberland Fusiliers from Fenham Barracks marching through Newcastle on the Victory Day parade, 8 June 1946.

11. The Royal Northumberland Fusiliers

Lord Clare's Irish Regiment, named so after Viscount Clare (its first colonel), was formed in Holland in 1673. The following year the colonelcy passed to Sir John Fenwick of Fenwick and Wallington and thus the regiment had its first connection with Northumberland and was restyled 'Fenwick's Regiment'.

In 1678 the regiment took part in its first important operation at the siege of Maastricht in Holland and were among the first British troops to use hand grenades at the siege of Mons that same year. In 1688 the regiment escorted the Prince of Orange when he landed at Brixham. King James withdrew and the Prince was crowned William III of England. The following year the regiment was placed on the English establishment, taking its foundation date from 5 June 1685, the day on which it first received pay from the British crown and was designated the 5th Regiment of Foot.

In 1690 the 5th was ordered to Ireland where rebellion had broken out and served with distinction in Brigadier-General Trelawney's Brigade at the Battle of the Boyne and went on to take part in the siege and capture of Athlone in 1691. After a brief return to England and an expedition to France the 5th proceeded to Martinique in 1693 after which it was ordered to return to the continent where it remained until the conclusion of the war in 1697. During the War of the Spanish Succession Gibraltar had been captured from the Spaniards in 1704 and the garrison of British units there was joined by the 5th from 1713. In 1727 the Spanish forces attacked the fortress again in an attempt to regain it. Depite four months of heavy bombardment the 5th and the garrison defended the outpost until the Spanish forces finally gave up.

A nineteenth-century depiction of the badge, motto and battle honours of the 5th Regiment of Northumberland Fusiliers. The badge of St George killing the dragon was first officially recorded as a distinction of the 5th Regiment of Foot used on regimental colours, drums, badges and other insignia in 1747.

A Battle Honour, a Captured Colour and a Fur Cap

The 5th's first battle honour was won during the Seven Years' War on 24 June 1762 at Wilhelmsthal, near Cassel, where the regiment led the attacking column. The French had been taken by surprise, abandoned their camp leaving their tents standing and went into retreat. A French division was thrown into the woods of Wilhelmstahl to cover the retirement but the 5th pressed forward, overcame all opposition, took more than twice its number in prisoners and were surrendered one standard, six colours and two canons. From that time on a third colour known as 'The Drummer's Colour' was carried in the rear rank of the band and drums to commemorate the victory. The men also exchanged their hats for French grenadier caps and retained the style as a distinction.

In 1768 Hugh, Earl Percy was appointed Colonel and led the Fifth as one of the first regiments sent to Boston, North America in 1774. The American War of Independence commenced the following year. At the Battle of Bunker's Hill the Fifth formed part of the body of troops ordered to attack the heights. It proved a costly day for the Fifth and General Burgoyne would comment that they 'behaved best and suffered the most'.

The Drummer's Colour

In 1836 the 5th were equipped as a Fusilier Regiment and styled 'Fifth Regiment of Foot or Northumberland Fusiliers' and the unique battle honour 'Wilhelmstahl' to be borne on the colours of the 5th was formally granted by George IV. Regulations did not permit any regiment to carry more than two colours but the Drummer's Colour was still carried on each anniversary of St George's Day (23 April) in disregard of regulations. Royal sanction 'to bear a commemorative banner only on St George's Days' was finally granted by George V in 1933. The tradition is carried on by the Royal Regiment of Fusiliers, now known as the Wilhelstahl Colour, it is carried by the youngest drummer of the battalion, trooping its colour on St George's Day.

An early nineteenth-century painting of 'The Drummer's Colour'. Prepared by Regimental Colour manufacturers, their interpretation of a regiment's prescribed designs could thus be approved by the regiment before producing the full-size painted colour on silk.

The Plume and the Hackle

France declared war against England in 1778 and the 5th were sent out as part of an expedition against the French West India Islands and the expedition took St Lucia. The French fleet arrived soon after and disembarked a force of 9,000 men against the British. They made three violent assaults to take the position but the French suffered heavy casualties, were repulsed each time and finally retired. The men of the 5th took the white feather plumes of the French Grenadiers and were granted the right to wear them in their hats as a distinction until 1829 when army regulations stated white feather plumes should be worn as standard for many British infantry units. The 5th were then granted a red-and-white plume with the red uppermost and are still worn with great pride as hackles in the berets of the Royal Regiment of Fusiliers today.

A Northumberland Regiment

The regiment left the West Indies in 1780 and in 1784 Earl Percy, having been colonel for fifteen years, was promoted to the Colonelcy of the 2nd Life Guards. In honour of their respected Commanding Officer the regiment received the denomination of the Northumberland Regiment that same year.

In 1799 the 5th was divided into two battalions of 800 men and both were sent back to Holland where they received the thanks of Prince William for their gallantry at the Battle of Winkle. After the disastrous Flushing expedition the regiment fought at Monte Video and Buenos Aires in 1807.

Above left: Three soldiers of the 5th Foot (Northumberland Fusiliers), 1835. Note their red over white plumes.

Above right: An early nineteenth-century recruiting poster for the 5th.

During the Peninsular War of 1808–14 the 5th distinguished itself earning twelve battle honours. The steel of the men of 2nd Battalion, the Fifth Foot, at the Battle of El Bodon, in the Province of Salamanca, Spain, on 25 September 1811 remains legendary. Major Ridge led the battalion forward to engage the French cavalry and recaptured the guns that had fallen into enemy hands. This act is believed to be the first successful line infantry bayonet charge against cavalry. The Duke of Wellington himself wrote of the men of the 5th: 'The conduct of the Fifth Regiment affords a memorable example of what the steadiness and discipline of the troops and their confidence in their officers, can effect in the most difficult and trying circumstances.'

Europe was at peace in 1814 but there was still war in America and the Fifth left Bordeaux for Canada where they were present at the Battle of Plattsburg on Lake Champlain in New York. The battle was lost and with it ended the last invasion of America during the War of 1812. The Fifth embarked for Europe in June 1815. After a brief stop at Portsmouth the Fifth disembarked at Ostend in July and arrived in Paris in August, thus missing the Battle of Waterloo.

Nicknames of The Northumberland Fusiliers

'The Shiners': An early nickname given to the 5th when in Ireland in 1769 for their smart turnout, pipeclayed leather equipment and shone buttons and badges.
'The Duke of Wellington's Bodyguard': The 5th was stationed in Fuenteguinaldo in the Province of Salamanca where the Duke of Wellington had his headquarters and being the only regiment there they soon acquired the nom de plume.
'The Fighting Fifth': Originated from a remark made my Wellington during the Peninsular War ('The ever fighting, often tried, but never failing Fifth').
'The Old and Bold': The Northumberland Fusiliers were certainly an old regiment synonymous with bravery and steel in battle.

Soldiers of the Queen

In September 1857 during the Indian Mutiny, five companies of the 5th led the first Brigade of Brigadier General Havelock's force into Lucknow, a town besieged by 50 or 60,000 mutineers and came 'under a most murderous fire'. The residency was only relieved in November 1857 when a second relief column commanded by Sir Colin Campbell fought their way into Lucknow and brought out the garrison. This second column included two further companies of the 5th, thus the regiment was involved in both the defence and relief of Lucknow. Cpl. Robert Grant, Pte Peter McManus and Pte Patrick McHale were all awarded the Victoria Cross for their gallant actions during the Mutiny. Over the preceding years the 5th continued its garrison duties in the far-flung corner of the British Empire and took part in the Second Afghan War and earned the battle honour Afghanistan in 1879–80 for their colours.

In 1881 the Childers Reforms saw the 5th Fusiliers formally designated as the Northumberland Fusiliers but the Roman numeral 'V' continued to feature in regimental insignia and the old habit of the regiment being simply referred to as the 5th Fusiliers never faded away.

THE FIRST & SECOND BATTALIONS.

The field service and parade dress uniforms of the Regular Army battalions of the Northumberland Fusiliers for both home and foreign service, 1897.

The latter years of the nineteenth century were marked by a series of campaigns and small wars for the men of the Northumberland Fusiliers including the Black Mountains Expedition otherwise known as the Hazara Expedition (1888), the Second Ashanti Expedition (1895–96) and the Sudan Expedition (1898) where they fought against the Mahdist forces at the Battle of Omdurman and earned the battle honour 'Khartoum'.

In 1899 1st Battalion, Northumberland Fusiliers, embarked for Cape Town to serve in the Anglo-Boer War (1899–1902). They fought in such notable battles as Belmont, Modder River and Magersfontein and were soon joined by the 2nd Battalion and both regular units raised mounted infantry companies, which did excellent work throughout the war.

The First World War

During the First World War the Northumberland Fusiliers expanded to a remarkable fifty-two battalions, making it the second largest line infantry regiment in the British Army, with only the eighty-eight battalions of the London Regiment surpassing them in greater number. Twenty-nine battalions of the Northumberland Fusiliers served overseas in a variety of theatres including Gallipoli, Egypt, Macedonia and Italy but were predominantly deployed to the Western Front.

There were a total of nineteen service battalions raised for the Northumberland Fusiliers between August 1914 and the early months of 1915, and all bar one of them were raised in Newcastle. The exception was 17th (Service) Battalion (N.E.R. Pioneers) raised by the North Eastern Railway Co. in Hull but it should not be forgotten that this battalion included many men from Northumberland.

Among the many 'New Army' battalions of the Northumberland Fusiliers were the 16th (Service) Battalion, the 'Newcastle Commercials', Tyneside Scottish Brigade (20th–23rd (Service) Battalions) and Tyneside Irish Brigade (24th–27th (Service) Battalions), who faced the hurricane of machine gunfire, 1 July 1916. Five thousand of them lay dead or wounded by sunset. No regiment lost more men than the Northumberland Fusiliers on the first day of the Somme.

Above: 'Kitchener' recruits for 13th (Service) Battalion, Northumberland Fusiliers, wearing 'Kitchener Blue' uniforms, Halton Park, Hampshire, 1914.

Below: Officers, warrant officers and sergeants of 21st (2nd Tyneside Scottish) Battalion, Northumberland Fusiliers, Longbridge Deverell, Wiltshire, 1915.

The Northumberland Fusiliers were granted sixty-seven battle honours for the First World War, five members of the regiment were awarded the Victoria Cross but being one of the largest infantry regiments with so many battalions in the thick of the action the war also claimed the lives of over 16,000 officers and men.

In George V's Silver Jubilee Honours of 1935 the Royal prefix was granted to six regiments in recognition of their services in the First World War and the Royal Northumberland Fusiliers were one of them. The following year the 5th Fusiliers were one of four line infantry regiments selected for conversion to Divisional Machine Gun or Divisional Support Battalions.

Left: The famous Tyneside Scottish 'Harder than Hammers' recruiting poster designed and printed by Andrew Reid & Co. Ltd, 1914.

Below: Pipe Major Jimmy Wilson (left), pipes and drums of 24th (1st Tyneside Irish) Battalion, Northumberland Fusiliers, *c.* 1914.

Right: CSM Richard Dale, 20th (1st Tyneside Scottish) Battalion, Northumberland Fusiliers, with his wife and child. Half his battalion became casualties on first day of the Somme, 1 July 1916; he was among them. CSM Dale has no known grave but is commemorated on the Thiepval Memorial.

Below: One of the most iconic and frequently reproduced images of the Great War, 'A Fag after a Fight' is usually unattributed. It actually shows privates from 1st Battalion, Northumberland Fusiliers, after the battle of St Eloi, on the Ypres salient, 27 March 1916.

Men of The Northumberland Fusiliers serving as part of the occupation forces of Germany, 1918–19.

The Second World War and After

The Royal Northumberland Fusiliers expanded to ten battalions during the Second World War:

1st Battalion: North Africa (1939 to May 1943) Egypt, Syria, Palestine and Italy (May 1943–45).

2nd Battalion: Mobilized at Connaught Barracks, Dover, Machine Gun Battalion, 4th Division, B.E.F. France (1939, evacuated from Dunkirk in June 1940). Invasion defence duties in Great Britain (June 1940–43), North Africa and Italy (June 1943 to December 1944) and Greece (December 1944 to May 1945).

4th Battalion – Motor Cycle Reconnaissance Battalion, 50th (Northumbrian) Division, B.E.F., France, evacuated from Dunkirk (1939 to June 1940). Invasion defence duties in Great Britain (June 1940 to June 1941), North Africa (August 1941 to September 1942). Disbanded as a battalion and formed 1, 2 and 3 Independent Machine-Gun Companies (1943 to June 1944), Normandy and the Low Countries (June 1944 to September 1944). Advance into Germany (October 1944 to May 1945).

5th Battalion (TA): Searchlight regiment serving on the home front through the Battle of Britain and beyond (1939 to May 1945) and in Norway (June 1945 to October 1945).

6th Battalion (TA): Duplicated and converted into two armoured units:

Men from 4th Battalion, Royal Northumberland Fusiliers, serving as part of Motor Cycle Reconnaissance Battalion, 50th (Northumbrian) Division, B.E.F., making friends with a local lady, 'somewhere in Belgium', 1940.

43rd (Northumberland) Battalion, Royal Tank Regiment – Home Defence, Motor Machine Gun Brigade and anti-invasion role (1939–41). Part of Experimental Army Tank Division developing Hobart's 'Funnies', e.g., Flail Tanks, Buffaloes, Kangaroos and D.D. Tanks, etc. (1942–44) and India (1945).

43rd (Northumberland) Battalion, Royal Tank Regiment– Home Defence, Motor Machine Gun Brigade with anti-invasion role (1939–41). Tank development work (1942–44), France and Germany (August 1944–45).

7th Battalion: Concentrated at Gosfoth Park shortly after embodiment and training at Alton Hampshire (1939 to March 1940). Machine Gun Battalion 51st (Highland) Division, Saar Area, Maginot Line, France. Many killed or became prisoners of war at St Valery (March 1940 to June 1940). Battalion rebuilt and retrained then served on Home Defences (June 1940 to August 1943), Training for Operation Overlord (August 1943 to June 1944) and France (June 1944 to (disbandment) 20 September 1944).

8th Battalion: Embodiment at Prudhoe and deployed to home front defences (1939 – April 1940), Motor Cycle Reconnaissance Battalion, 23rd (Northumbrian) Division, France, Arras defences (April 1940 – evacuated from Dunkirk and La Panne, May 1940). Rebuilt and re-equipped and designation changed to 3rd Reconnaissance Regiment (N. F.) in

spring 1941 (June 1940 to August 1943). Training for Operation Overlord (August 1943 to June 1944), landed on D-Day, 6 June 1944, with 3rd Infantry Division, France and Low Countries (June 1944 to September 1944), and the advance into Germany (October 1944 to May 1945).

9th Battalion: Embodies and sent as Machine Gun Battalion, 23rd (Northumbrian) Division, Monchy Breton, France (1939 – evacuated from Dunkirk May 1940). Embarked for the Middle East with 18th Division (October 1940). Diverted to defend Singapore, landed 5 February 1942, fought in defence of Singapore until the surrender. All troops were then entered into the living hell that was captivity in the hands of the Japanese until final victory in the Far East in September 1945. Many of these men suffered from the maltreatment they received while prisoners of war for the rest of their lives.

10th (Home Defence) Battalion: Formed from 40 Group National Defence Company, redesignated 30th (H. D.) Battalion, Northumberland Fusiliers, December 1941 (1939 to August 1943). Although styled 'Home Defence', the battalion was ordered to Algiers, North Africa (August 1943 to May 1944), Naples, Italy (1944), and a garrison unit in Malta (1944–45).

70th Battalion: Formed at Gosforth and Benwell areas as a Young Soldiers battalion (1940). Headquarters remained at Gosforth with companies spread out as far as 50 miles from HQ on airfield defence work (1941–42). November 1942, battalion was at North Seaton Hall, Newbiggin, when it converted to No. 98 Primary Training Centre and all surplus officers and men were transferred to other units.

One of the companies of 9th Battalion, Royal Northumberland Fusiliers, shortly before their departure for Singapore in October 1941.

The depot remained at Fenham Barracks, which became a machine-gun training centre until August 1941 when the MG training was centralised at Chester and small 'Depot Party' remained at Fenham. In turn this centre transferred to larger premises at Blacon and the regimental depots moved there too. In December 1946 No. 5 Primary Training Centre was formed at Fenham Barracks and the regimental depot was re-established there.

Just a few years after the Second World War (for which the 5th were awarded twenty-eight battle honours) the Fifth would see their last major deployment, to Korea (1950–51), where they fought with distinction on the River Imjin. But times were changing, old regiments were being merged to create new modern army units and in 1968 the Royal Northumberland Fusiliers was amalgamated with other Fusilier Regiments to create the new Royal Regiment of Fusiliers.

Depot band of the Royal Northumberland Fusiliers, Fenham Barracks, 1941.

12. Victoria Cross Heroes of Two World Wars

Pte Frederick William Dobson VC, 2nd Battalion, Coldstream Guards (1886–1935)

The first Northumberland-born man to be awarded the VC during the First World War. Frederick was born in Ovingham. He had originally enlisted into the Coldstream Guards in 1906 and had left the Army in 1909. He married in 1911 and made a home in Meadowell, North Shields. Remaining on the Army Reserve he was recalled to the colours in 1914 and was in action at Chavanne on the Aisne on 28 September when he volunteered to go out under heavy fire not just once but twice to bring in two wounded comrades.

2nd-Lt James Edgar Leach VC (1892–1958), 2nd Battalion, the Manchester Regiment

Born in North Shields in 1892. On 29 October 1914, near Festubert, Leach and Sergeant John Hogan were awarded the VC for their decisive actions. Their citation states:

> For conspicuous bravery when, after their trench had been taken by the Germans, and after two attempts at recapture had failed, they voluntarily decided on the afternoon of the same day to recover the trench themselves, and, working from traverse to traverse at close quarters with great bravery, they gradually succeeded in regaining possession, killing eight of the enemy, wounding two, and making sixteen prisoners.

Piper Daniel Logan Laidlaw VC (1875–1950), 7th Battalion, the King's Own Scottish Borderers, 'The Piper of Loos'

Born Little Swinton, Berwickshire, his citation states:

> On 25 September 1915 during the Battle of Loos at Hill 70, prior to an assault on enemy trenches and during the worst of the bombardment, Piper Laidlaw, seeing that his company was shaken with the effects of gas, with complete disregard for danger, mounted the parapet and, marching up and down, played his company out of the trench. The effect of his splendid example was immediate and the company dashed to the assault. Piper Laidlaw continued playing his pipes even after he was wounded and until the position was won.

He was buried in St Cuthbert's churchyard, Norham, Northumberland. His Victoria Cross and other medals are on display at the King's Own Scottish Borderers Museum in Berwick-on-Tweed.

Above left: 2nd-Lt James Leach VC.

Above right: Piper Daniel Laidlaw VC.

Below: A vivid depiction of how Piper Daniel Laidlaw won his VC and entered into legend as 'The Piper of Loos'.

Above left: Captain John Liddell VC.

Above right: Pte Ernest Sykes being awarded his VC by King George V.

Capt. John Aidan Liddell VC (1888–1915), Princess Louise's Argyll and Sutherland Highlanders, 31 July 1915

Born in Newcastle and educated at Stonyhurst College and Balliol College, Oxford, he was commissioned into the Argyll and Sutherland Highlanders just before the outbreak of war. After being decorated for his devotion to duty in the trenches he volunteered for the Royal Flying Corps. Joining No. 7 Squadron, Royal Flying Corps, he was flying a reconnaissance mission over Ostend, Belgium, on 31 July 1915. His aircraft was raked by machine-gun fire and despite being badly wounded in his right thigh and dropping 3,000 feet he recovered the plane, brought it back to Allied lines and saved the life of the *Observer*.

Liddell died of his wounds a month later at De Panne, Flanders, Belgium, on 31 August 1915, aged twenty-seven. He was buried in the Holy Ghost Cemetery in Basingstoke.

Pte Ernest Sykes VC (1885–1949), 27th (Service) Battalion (4th Tyneside Irish), Northumberland Fusiliers

Ernie Sykes was born in Mossley in the West Riding of Yorkshire and in the years before the First World War he worked as a platelayer for the London & North Western Railway at Micklehurst, Cheshire. On 9 April 1917 during the Battle of Arras his battalion was held up by intense fire from two sides and were suffering heavy casualties. His citation states:

> For most conspicuous bravery and devotion to duty when his battalion in attack was held up about 350 yards in advance of our lines by intense fire from front and flank, and

suffered heavy casualties. Pte. Sykes, despite this heavy fire, went forward and brought back four wounded – he made a fifth journey and remained out under conditions which appeared to be certain death, until he had bandaged all those who were too badly wounded to be moved. These gallant actions, performed under incessant machine gun and rifle fire, showed an utter contempt of danger.

Ernie survived the war and returned to work on the railway where a LNWR 'Claughton' Class was named after him. His Victoria Cross is displayed at the Fusiliers of Northumberland Museum at Alnwick Castle.

L/Cpl Thomas Bryan VC (1882–1945), 25th (Service) Battalion, (2nd Tyneside Irish), Northumberland Fusiliers

Born in Stourbridge, Worcestershire, he grew up in Castleford, Yorkshire. At the Battle of Arras on 9 April 1917 his battalion were held up by machine-gun fire and suffering heavy casualties. His citation states:

Lance-Corporal Bryan although wounded, went forward alone in order to silence a machine-gun which was inflicting much damage. He worked his way along the communication trench, approached the gun from behind, disabled it and killed two of the team. The results obtained by Lance-Corporal Bryan's action were very far-reaching.

After the war Tom returned to the pits in Yorkshire and finally set himself up as a greengrocer in Bentley, near Doncaster.

2nd-Lt John Scott 'Jack' Youll VC (1897–1918), 11th (Service) Battalion, Northumberland Fusiliers

Born at Thornley in County Durham, he had been an electrician at Thornley Colliery before the war. He joined the Royal Engineers in 1916 and was commissioned into the Northumberland Fusiliers in August 1917. During the Battle of Asiago, Italy, on 15 June 1918 the patrol he was commanding came under fire. His citation states:

Sending his men back to safety he remained to watch the situation and then, unable to rejoin his company, he reported to a neighbouring unit where he took command of a party of men from different units, holding his position against enemy attack until a machine-gun opened fire behind him. He rushed and captured the gun, killing most of the team and opened fire, inflicting heavy casualties. He then carried out three separate counterattacks, driving the enemy back each time.

Jack was killed in action at the Battle of Vittorio Veneto on 27 October 1918 and was buried in Giavera British Cemetery, Veneto, Italy.

2nd-Lt James Bulmer Johnson VC (1883–1943), 36th Battalion, Northumberland Fusiliers

James was born in Widdrington Station, Northumberland, the son of an engine fitter, he grew up in Walker and Benwell. He initially joined the Royal Horse Guards as a trooper

but was commissioned into the Northumberland Fusiliers in 1918. On 14 October 1918, south – west of Wez Macquart, France, his citation states:

> During operations by strong patrols, Second Lieutenant Johnson repelled frequent counter-attacks and for six hours, under heavy fire, he held back the enemy. When at length he was ordered to retire he was the last to leave the advanced position carrying a wounded man. Three times subsequently this officer returned and brought in badly wounded men under intense enemy machine-gun fire.

Lt Johnson was the only Northumberland-born man ever to be awarded the Victoria Cross while serving in the Northumberland Fusiliers. He died in Plymouth Hospital and was cremated at Efford Crematorium. He left his VC to his regiment and it is displayed at the Fusiliers of Northumberland Museum at Alnwick Castle.

Pte Wilfred Wood VC (1897–1982), 10th (Service) Battalion, Northumberland Fusiliers

Wilf was born in Stockport, Cheshire, and had worked as a cleaner at the Stockport locomotive depot before the outbreak of war. Near Casa Van during the Battle of Vittorio Veneto, Italy, 28 October 1918. His citation states:

> When a unit on the right flank having been held up by hostile machine guns and snipers, Pte. Wood, on his own initiative, worked forward with his Lewis gun, enfiladed the enemy machine-gun nest, and caused 140 enemy to surrender. The advance was continued till a hidden machine gun opened fire at point blank range. Without a moment's hesitation Pte. Wood charged the machine gun, firing his Lewis gun from the hip at the same time. He killed the machine-gun crew, and without further orders pushed on and enfiladed a ditch from which three officers and 160 men subsequently surrendered.

After the war Wilf returned to the railway and spent the rest of his working life there. A LNWR Claughton Class locomotive was named after him in 1922.

2nd-Lt Donald Simpson Bell VC (1890–1916) 9th (Service) Battalion, the Green Howards (Alexandra, Princess of Wales's Own Yorkshire Regiment)

Born in Harrogate, he played for Crystal Palace, Newcastle United's reserve side and Bishop Auckland. He joined up in 1914 and soon obtained a commission in the Green Howards. On 5 July 1916 he was at Horse Shoe Trench near La Boiselle on the Somme. His citation states:

> During an attack a very heavy enfilade fire was opened on the attacking company by a hostile machine gun. 2nd Lt. Bell immediately, and on his own initiative, crept up a communication trench and then, followed by Corpl. Colwill and Pte. Batey, rushed across the open under very heavy fire and attacked the machine gun, shooting the firer with his revolver, and destroying gun and personnel with bombs. This very brave act saved many lives and ensured the success of the attack. Five days later this very gallant officer lost his life performing a very similar act of bravery.

2nd-Lt Donald Simpson Bell.

Donald was killed in action on 10 July 1916. He was buried at Gordon Dump Cemetery near Albert, France. Donald Simpson Bell remains the only English professional footballer to have been awarded the Victoria Cross.

Sgt Hugh Cairns VC (1896–1918), 46th (South Saskatchewan) Battalion, Canadian Expeditionary Force

Born in Ashington, Hugh moved with his family to Canada and settled in Saskatoon, Saskatchewan, in 1911. On 1 November 1918 he was in Valenciennes, near Marly, France. His platoon was suddenly raked by machine-gun fire. His citation states:

> Without a moment's hesitation Sgt. Cairns seized a Lewis gun and single-handed, in the face of direct fire, rushed the post, killed the crew of five, and captured the gun. Later, when the line was held up by machine-gun fire, he again rushed forward, killing 12 enemy and capturing 18 and two guns.
>
> Subsequently, when the advance was held up by machine guns and field guns, although wounded, he led a small party to outflank them, killing many, forcing around fifty to surrender, and capturing all the guns. After consolidation he went with a battle patrol to exploit Marly and forced 60 enemy to surrender. Whilst disarming this party he was severely wounded. Nevertheless, he opened fire and inflicted heavy losses. Finally he was rushed by about 20 enemy and collapsed from weakness and loss of blood.

Sgt Cairns died from his wounds the following day and was buried in Auberchicourt British Cemetery, France.

Captain James Joseph Bernard Jackman VC (1916–41), 1st Battalion, Royal Northumberland Fusiliers

Born in Dunlaoghaire, Co. Dublin, Ireland, he entered Sandhurst from Stonyhurst in 1936 and was gazetted to the Royal Northumberland Fusiliers. On 25 November 1941

Captain Jackman was in command of a machine-gun company (Z Company) during a tank attack on the Ed Duda ridge, South East of Tobruk, Libya. His citation states:

> As the tanks reached the crest of the rise they were met by extremely intense fire from a large number of guns of all descriptions: the fire was so heavy that it was doubtful for a moment whether the Brigade could maintain its hold on the position.
>
> The tanks having slowed to "hull-down" positions, settled to beat down the enemy fire, during which time Captain Jackman rapidly pushed up the ridge leading his Machine Gun trucks and saw at once that Anti-Tank Guns were firing at the flank of the tanks, as well as the rows of batteries which the tanks were engaging on their front.
>
> He immediately started to get his guns into action as calmly as though he were on manoeuvres and so secured the right flank. Then, standing up in the front of his truck, with calm determination he led his trucks across the front between the tanks and the Huns – there was no other road to get them into action on the left flank.
>
> Most of the tank commanders saw him, and his exemplary devotion to duty regardless of danger not only inspired his own men but clinched the determination of the tank crews never to relinquish the position which they had gained.
>
> Throughout he coolly directed the guns to their positions and indicated targets to them and at that time seemed to bear a charmed life but later he was killed while still inspiring everyone with the greatest confidence by his bearing.

James Jackman VC was buried in the Torbruk War Cemetery. He was the only soldier serving with the Royal Northumberland Fusiliers to receive the Victoria Cross during the Second World War.

Pte Adam Wakenshaw VC (1914–42) 9th Battalion, Durham Light Infantry

Adam Wakenshaw was born the youngest of six children in a poor but hard-working family of a labourer in Newcastle. When war broke out he left his labouring job and joined the DLI. On 27 June 1942, Pte Wakenshaw was a member of the crew of a 2-pounder anti-tank gun south of Mersa Matruh on the Egyptian coast. An enemy vehicle towing a light gun came within short range and his gun opened fire and succeeded in immobilising the enemy vehicle, but another mobile gun came into action and killed or seriously wounded everyone in Wakenshaw's gun crew. His citation states:

> Under intense fire, Private Wakenshaw crawled back to his gun. Although his left arm was blown off, he loaded the gun with one arm and fired five more rounds, setting the tractor on fire and damaging the light gun. A direct hit on the ammunition finally killed him and destroyed the gun. This act of conspicuous gallantry prevented the enemy from using their light gun on the infantry Company which was only 200 yards away. It was through the self sacrifice and courageous devotion to duty of this infantry anti-tank gunner that the Company was enabled to withdraw in safety.

Pte Adam Wakenshaw was buried in the El Alamein War Cemetery.